Portland Community College

WITHDRAWN

P9-AEX-708

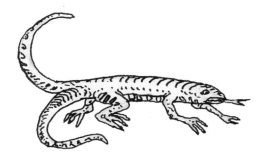

DALÍ

BY
BAUDOIN

SELF MADE HERO

This work was initiated by Jeanne Alechinsky, and was first
published under her direction for Éditions du Centre Pompidou,
in collaboration with José-Louis Bocquet for the "Aire Libre"
collection of Éditions Dupuis

Chronology and bibliography: Jeanne Alechinsky
Layouts: Philippe Ghielmetti

Image rights of Salvador Dalí reserved,
Fundació Gala-Salvador Dalí, Figueres, 2012

For the works of Salvador Dalí: © Salvador Dalí,
Fundació Gala-Salvador Dalí, ADAGP, Paris, 2012

© Dupuis/Éditions du Centre Pompidou, 2012.
www.dupuis.com. All rights reserved.

Dupuis would like to thank Marion Diez, Amarante Szidon and
Irène Tsuji from the Éditions du Centre Pompidou, as well as
the Gala-Salvador Dalí Foundation in Figueres.

First published in English in 2016
by SelfMadeHero
139-141 Pancras Road
London NW1 1UN
www.selfmadehero.com

Written and illustrated by Baudoin
Translated from French by Edward Gauvin

English edition
Publishing Director: Emma Hayley
Sales & Marketing Manager: Sam Humphrey
Publishing Assistant: Guillaume Rater
UK Publicist: Paul Smith
US Publicist: Maya Bradford
Designer: Txabi Jones
With thanks to: Dan Lockwood

Cet ouvrage a bénéficié du soutien des Programmes d'aide
à la publication de l'Institut français.

All rights reserved. No portion of this book may be reproduced,
stored in a retrieval system, or transmitted in any form or by
any means, mechanical, electronic, photocopying, recording,
or otherwise, without written permission from the publisher.

A CIP record for this book is available from the British Library

ISBN: 978-1-910593-15-8

10 9 8 7 6 5 4 3 2 1

Printed and bound in Slovenia

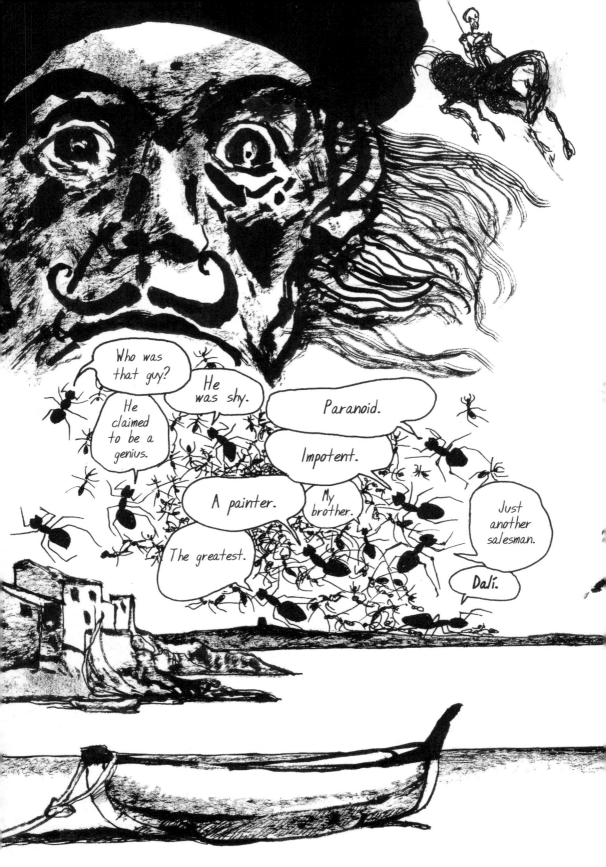

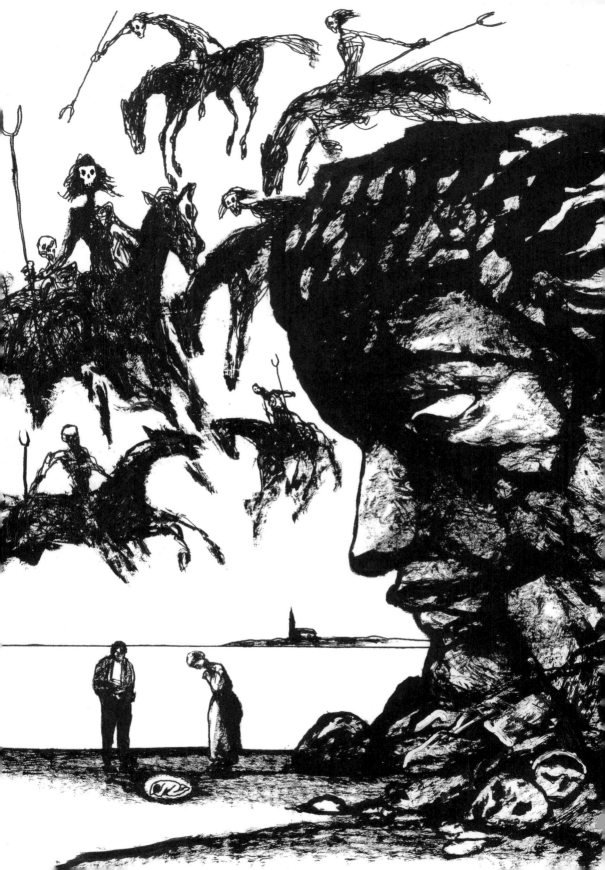

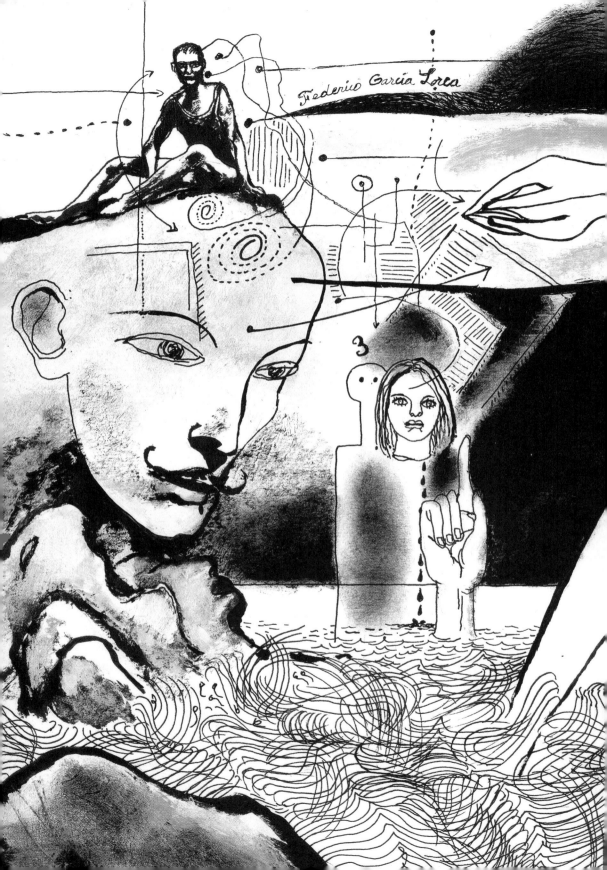

Federico García Lorca

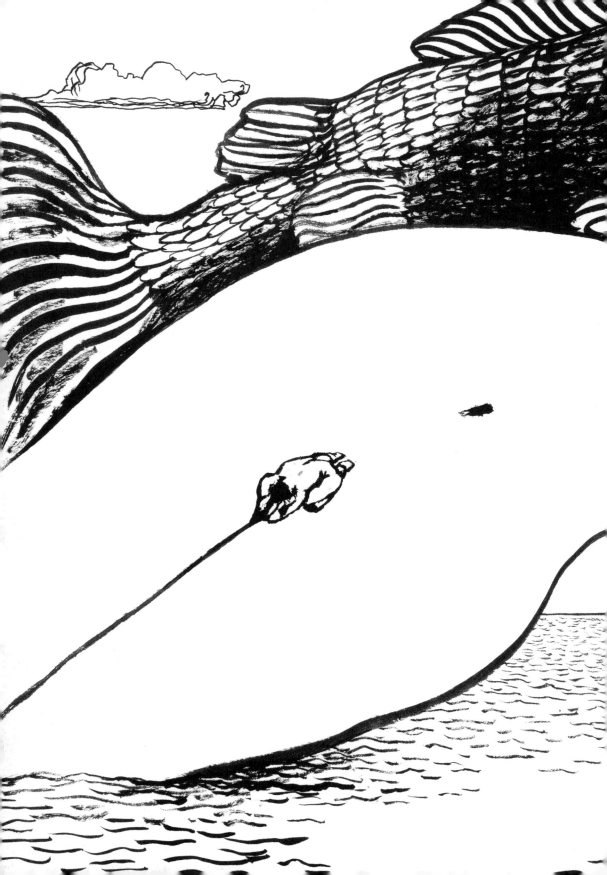

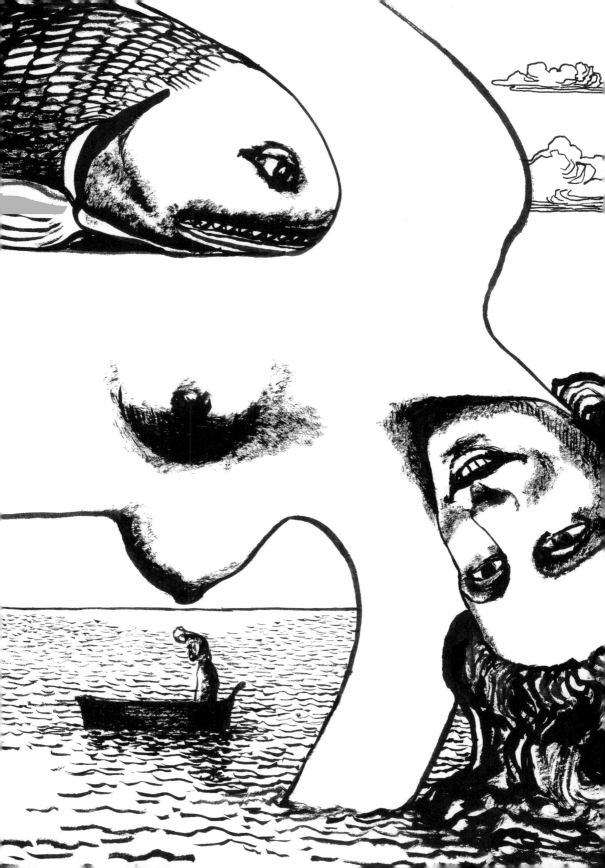

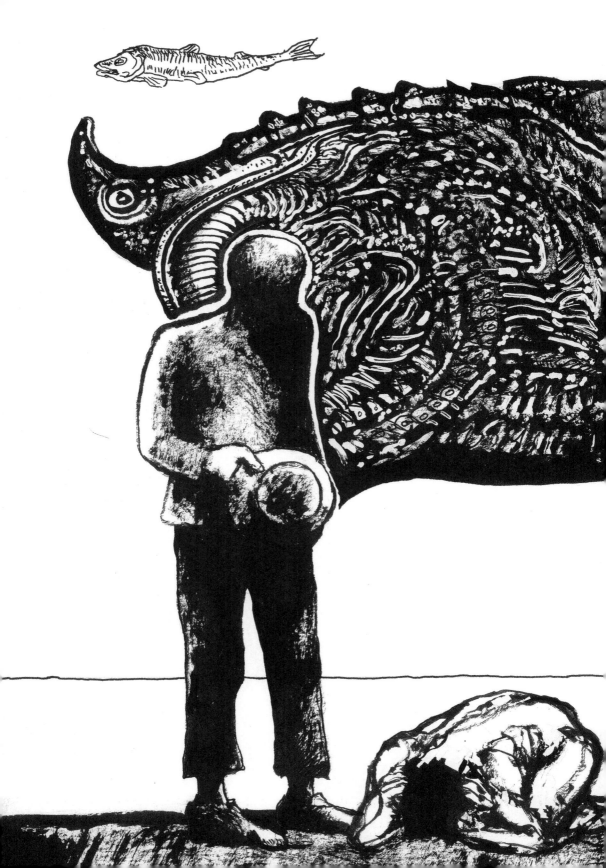

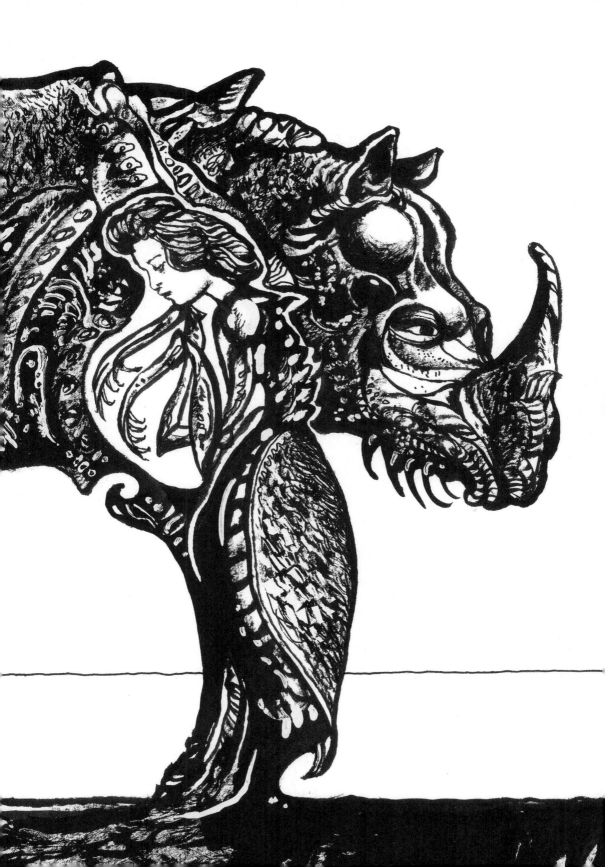

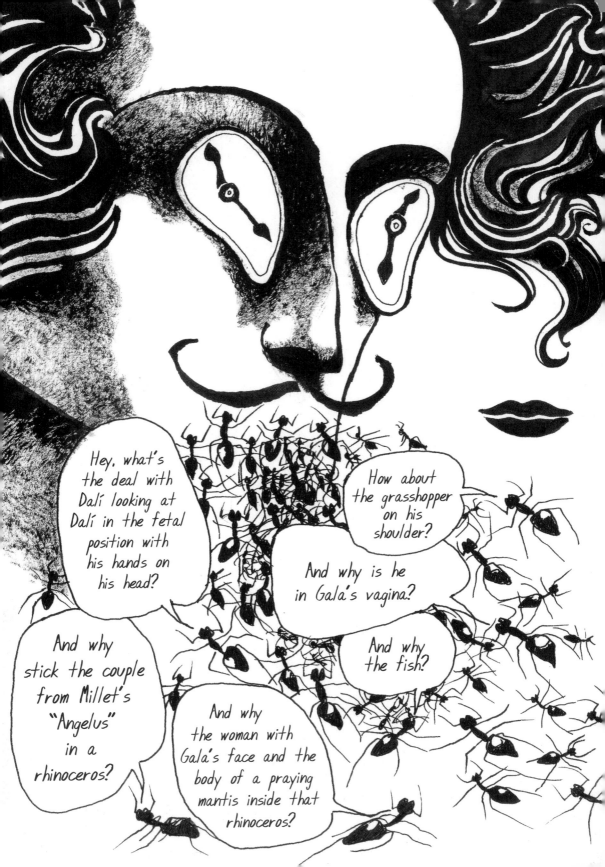

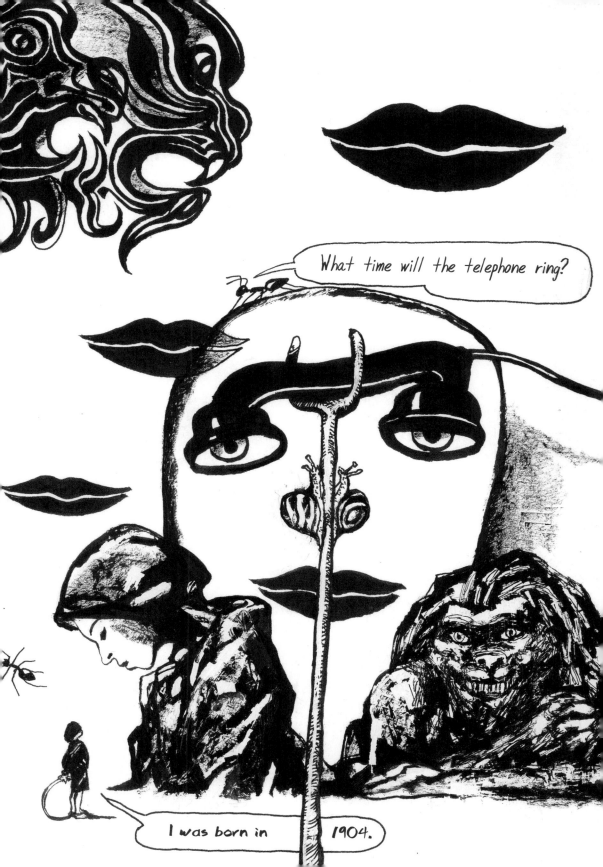

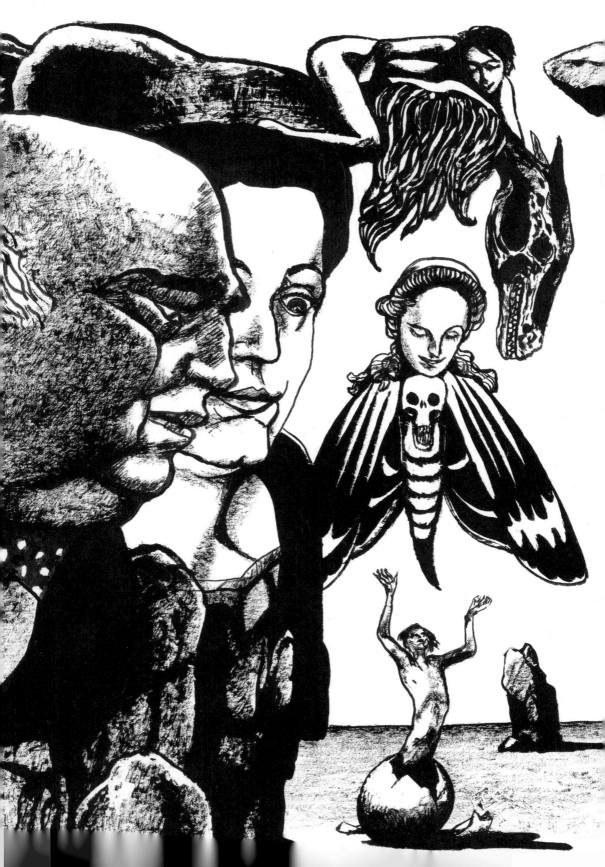

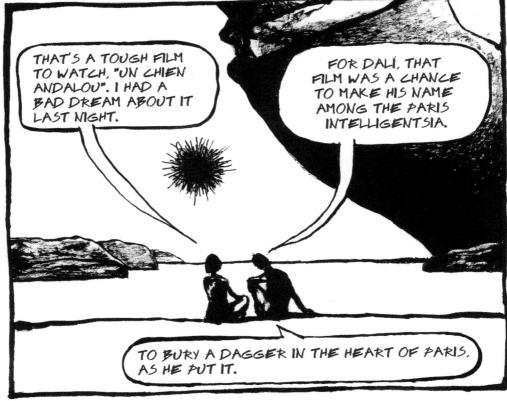

THAT'S A TOUGH FILM TO WATCH, "UN CHIEN ANDALOU". I HAD A BAD DREAM ABOUT IT LAST NIGHT.

FOR DALÍ, THAT FILM WAS A CHANCE TO MAKE HIS NAME AMONG THE PARIS INTELLIGENTSIA.

TO BURY A DAGGER IN THE HEART OF PARIS, AS HE PUT IT.

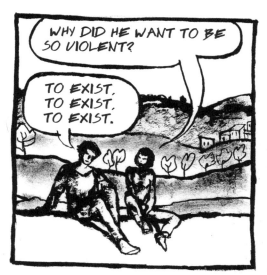

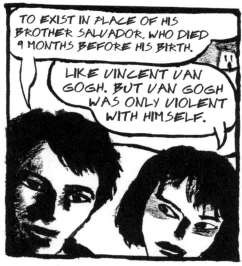

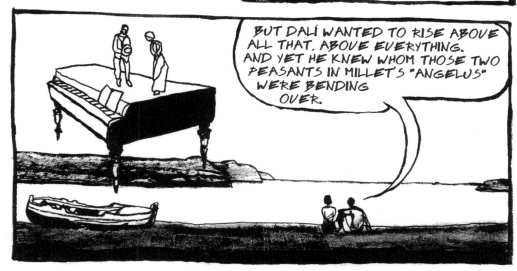

HIS CHILDHOOD IS SOWN WITH EXAMPLES OF HIS NEED TO EXIST. ONE EVENING, HIS PARENTS HAD FRIENDS OVER. EVERYONE WAS TALKING ABOUT A COMET THAT WOULD BE PASSING NEAR THE EARTH.

WHEN NIGHT FELL, THEY WENT UP TO THE BALCONY TO TRY TO SPOT THE COMET. LITTLE DALÍ WAS AFRAID.

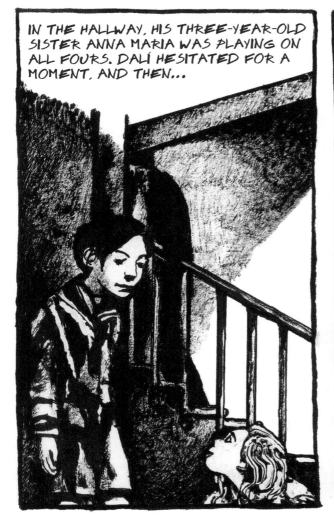

IN THE HALLWAY, HIS THREE-YEAR-OLD SISTER ANNA MARIA WAS PLAYING ON ALL FOURS. DALÍ HESITATED FOR A MOMENT, AND THEN...

...HE KICKED HER RIGHT IN THE HEAD. EMBOLDENED BY THIS ACT, FILLED WITH JOY, HE CLIMBED THE STAIRS. BUT HIS FATHER HAD SEEN HIM. HE LOCKED THE BOY IN HIS OFFICE UNTIL DINNER.

DALÍ NEVER SAW THE COMET.
THAT PUNISHMENT REMAINED AMONG THE WORST MEMORIES OF
HIS LIFE. HE SCREAMED UNTIL HE LOST HIS VOICE. HIS PARENTS
WERE FRIGHTENED. DALÍ TOOK ADVANTAGE OF THIS.

JUST BECAUSE HE KICKED HIS SISTER DIDN'T MEAN HE
DIDN'T LOVE HER. SOON AFTER, A DOCTOR CAME TO THE
HOUSE TO PIERCE THE LITTLE GIRL'S EARS. DALÍ FOUND THIS
OPERATION HORRIFYING.
 HE WANTED TO STOP IT AT ANY COST.

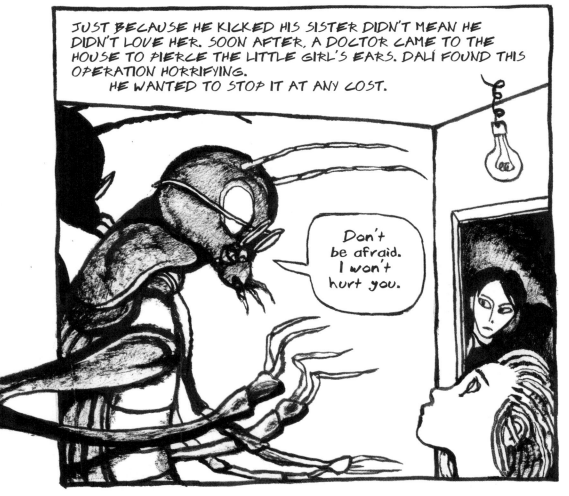

Don't
be afraid.
I won't
hurt you.

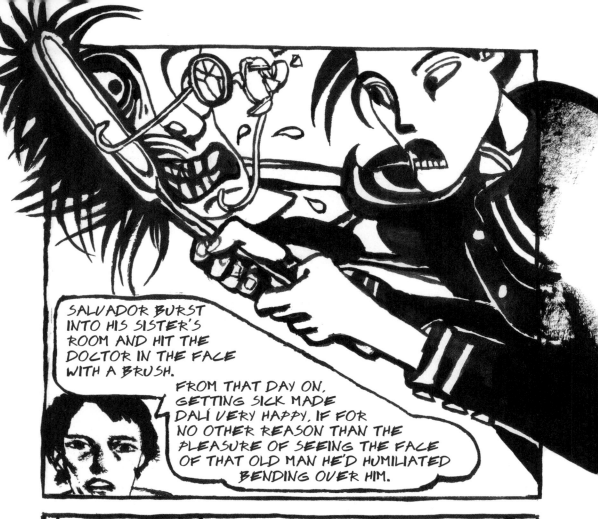

SALVADOR BURST INTO HIS SISTER'S ROOM AND HIT THE DOCTOR IN THE FACE WITH A BRUSH.

FROM THAT DAY ON, GETTING SICK MADE DALÍ VERY HAPPY, IF FOR NO OTHER REASON THAN THE PLEASURE OF SEEING THE FACE OF THAT OLD MAN HE'D HUMILIATED BENDING OVER HIM.

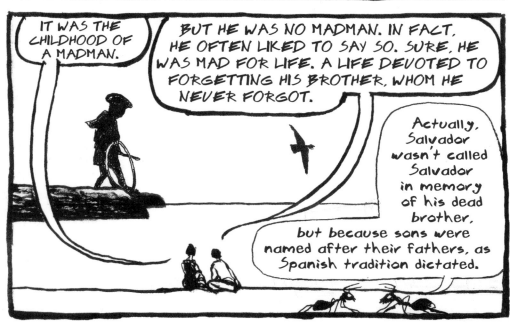

IT WAS THE CHILDHOOD OF A MADMAN.

BUT HE WAS NO MADMAN. IN FACT, HE OFTEN LIKED TO SAY SO. SURE, HE WAS MAD FOR LIFE. A LIFE DEVOTED TO FORGETTING HIS BROTHER, WHOM HE NEVER FORGOT.

Actually, Salvador wasn't called Salvador in memory of his dead brother, but because sons were named after their fathers, as Spanish tradition dictated.

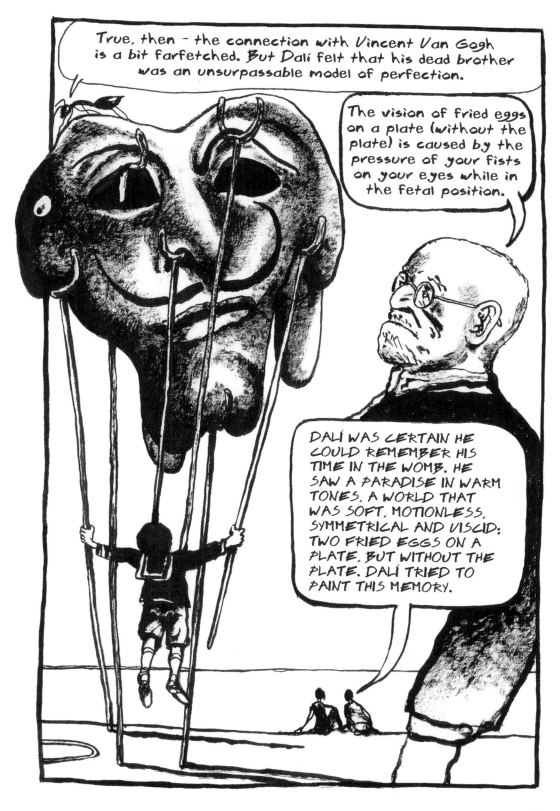

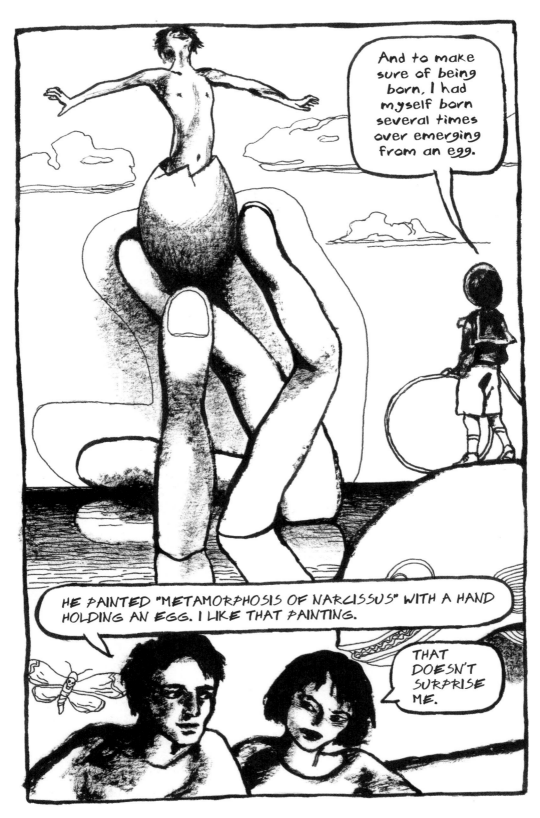

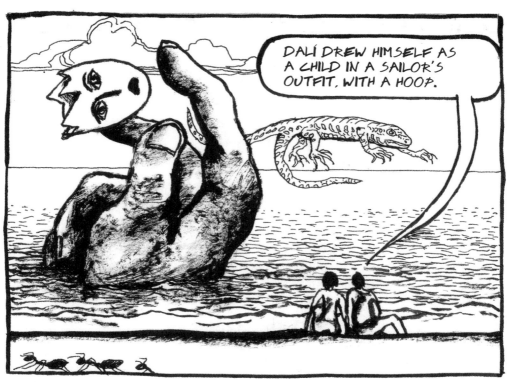

DALÍ DREW HIMSELF AS A CHILD IN A SAILOR'S OUTFIT, WITH A HOOP.

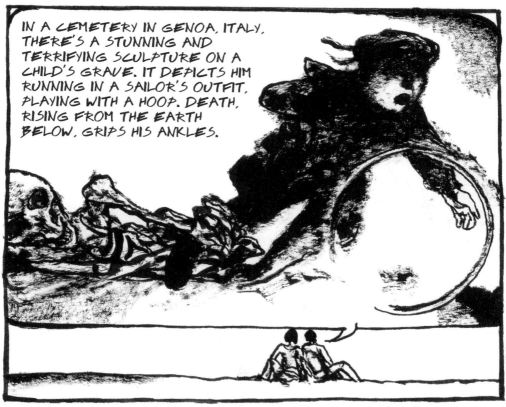

IN A CEMETERY IN GENOA, ITALY, THERE'S A STUNNING AND TERRIFYING SCULPTURE ON A CHILD'S GRAVE. IT DEPICTS HIM RUNNING IN A SAILOR'S OUTFIT, PLAYING WITH A HOOP. DEATH, RISING FROM THE EARTH BELOW, GRIPS HIS ANKLES.

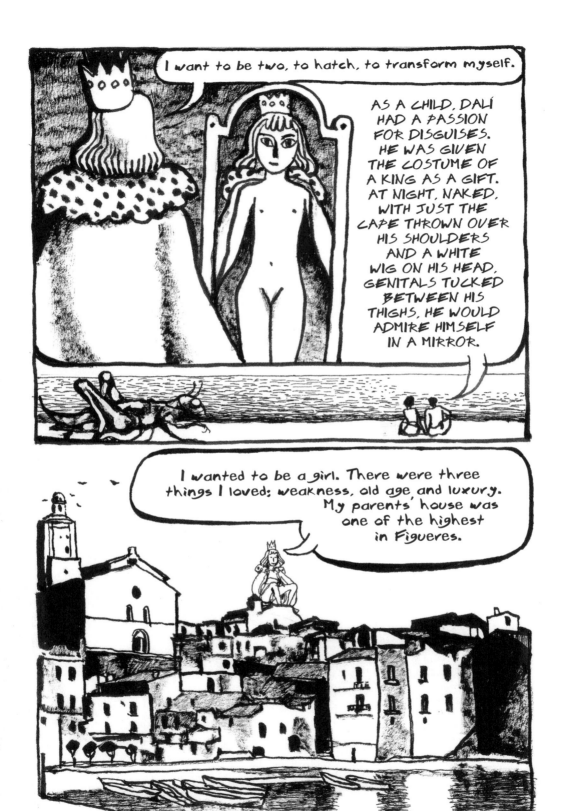

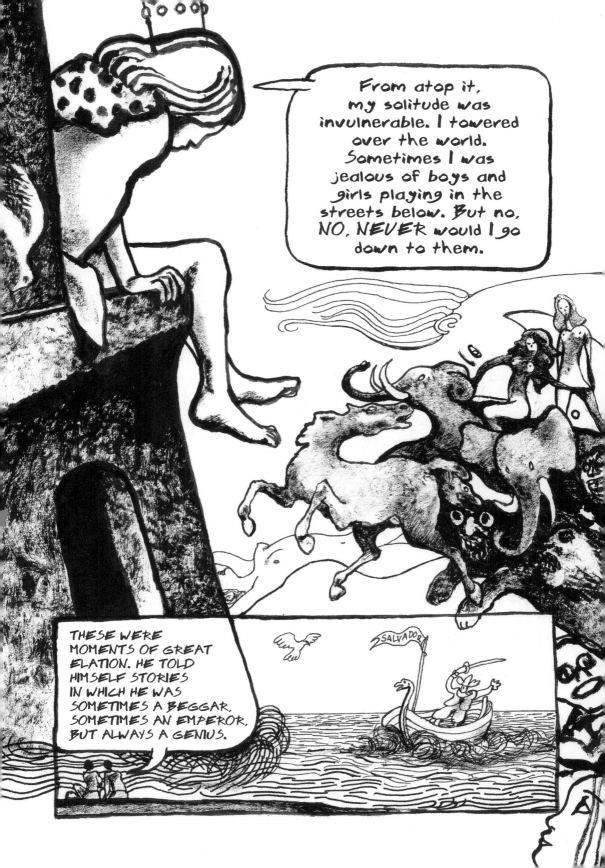

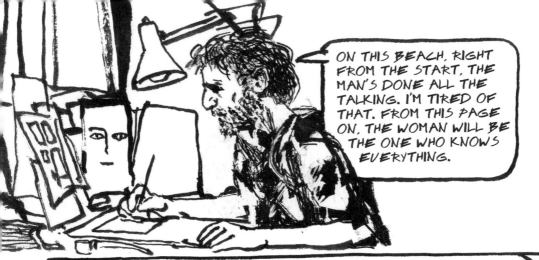

ON THIS BEACH, RIGHT FROM THE START, THE MAN'S DONE ALL THE TALKING. I'M TIRED OF THAT. FROM THIS PAGE ON, THE WOMAN WILL BE THE ONE WHO KNOWS EVERYTHING.

WHEN SALVADOR TURNED 12, HIS PARENTS DECIDED TO SEND HIM TO LIVE WITH SOME FRIENDS OF THEIRS IN THE COUNTRYSIDE NEAR FIGUERES. AN ESTATE OF THE PICHOT FAMILY. IT WAS CALLED "EL MOLINO DE LA TORRE". THERE WAS INDEED A MILL AND A TOWER. A MAGICAL PLACE.

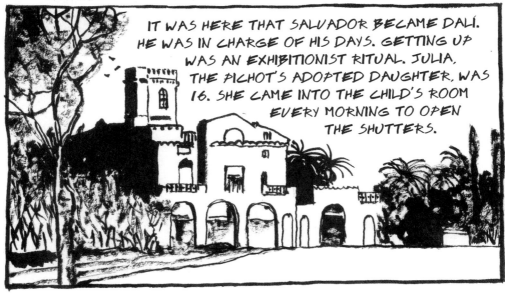

IT WAS HERE THAT SALVADOR BECAME DALÍ. HE WAS IN CHARGE OF HIS DAYS. GETTING UP WAS AN EXHIBITIONIST RITUAL. JULIA, THE PICHOT'S ADOPTED DAUGHTER, WAS 16. SHE CAME INTO THE CHILD'S ROOM EVERY MORNING TO OPEN THE SHUTTERS.

HE WOULD WAKE UP BEFORE JULIA'S
ARRIVAL AND UNDRESS, MAKING UP A
NEW POSE EVERY DAY. HE BELIEVED
HIMSELF VERY HANDSOME.

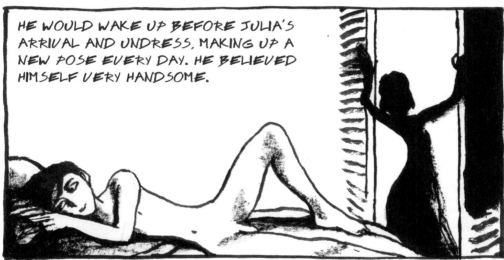

HE WOULD PICK A POSE THAT STRUCK
HIM AS PARTICULARLY DISCONCERTING
FOR JULIA AND HIMSELF, THEN LIE
WAITING IN DELIGHT FOR THE GIRL.
THAT SHE THEN SAW HIM NAKED WAS
THE ULTIMATE REWARD.

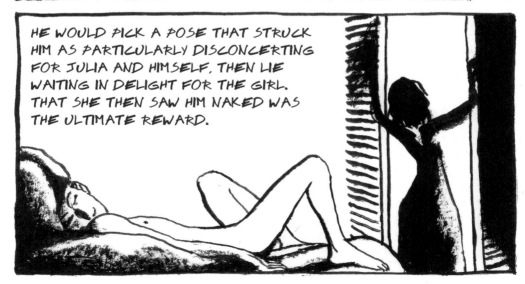

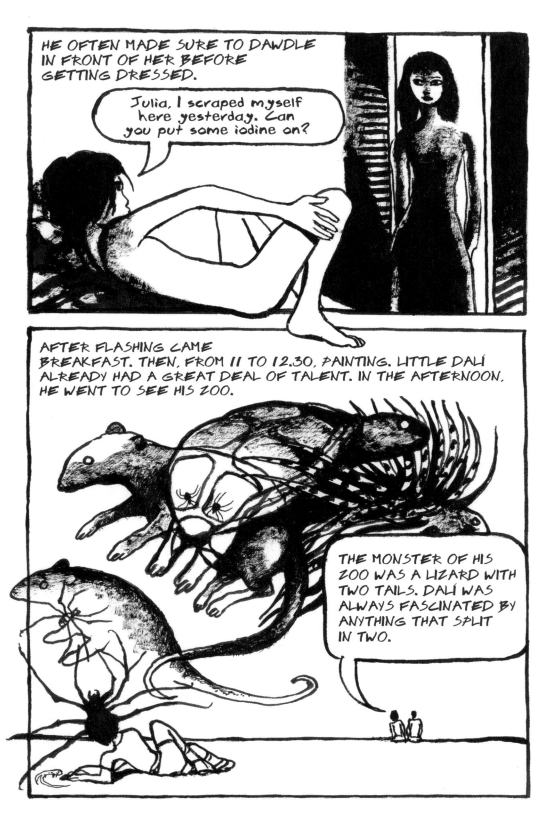

HE OFTEN MADE SURE TO DAWDLE IN FRONT OF HER BEFORE GETTING DRESSED.

Julia, I scraped myself here yesterday. Can you put some iodine on?

AFTER FLASHING CAME BREAKFAST. THEN, FROM 11 TO 12.30, PAINTING. LITTLE DALÍ ALREADY HAD A GREAT DEAL OF TALENT. IN THE AFTERNOON, HE WENT TO SEE HIS ZOO.

THE MONSTER OF HIS ZOO WAS A LIZARD WITH TWO TAILS. DALÍ WAS ALWAYS FASCINATED BY ANYTHING THAT SPLIT IN TWO.

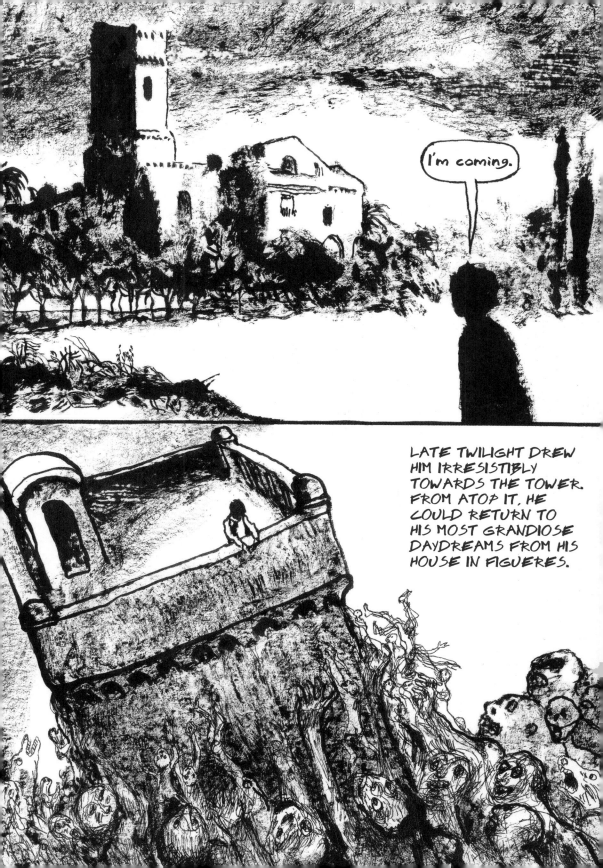

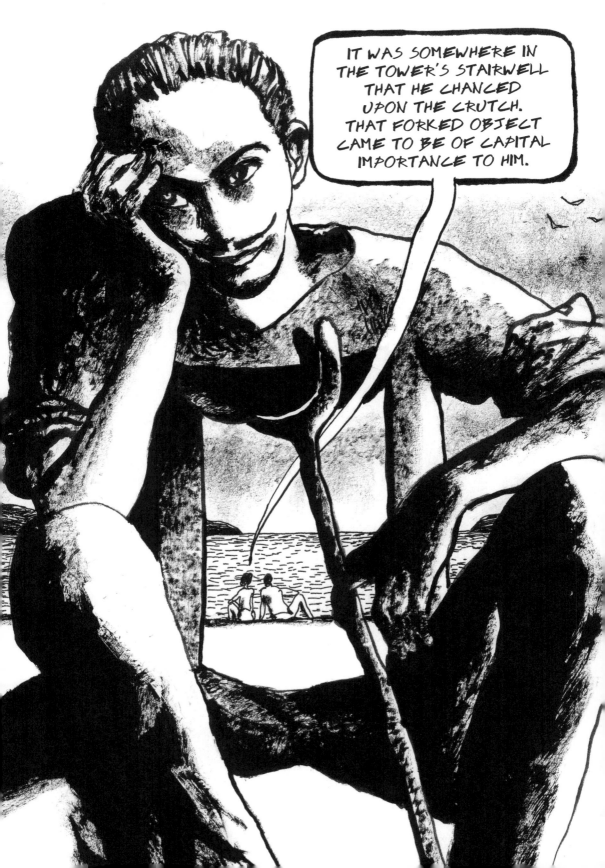

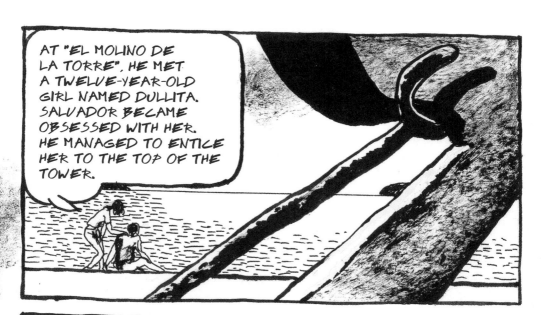

AT "EL MOLINO DE LA TORRE", HE MET A TWELVE-YEAR-OLD GIRL NAMED DULLITA. SALVADOR BECAME OBSESSED WITH HER. HE MANAGED TO ENTICE HER TO THE TOP OF THE TOWER.

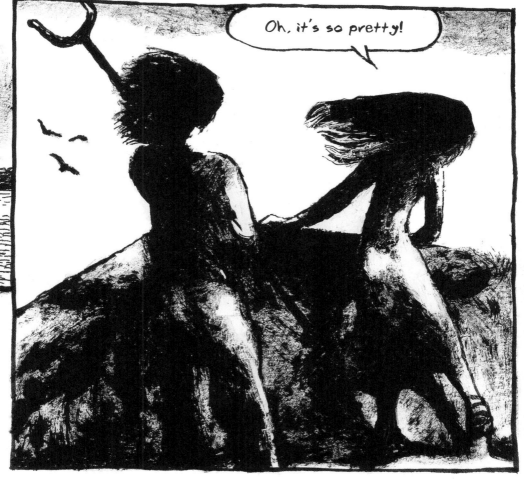

Oh, it's so pretty!

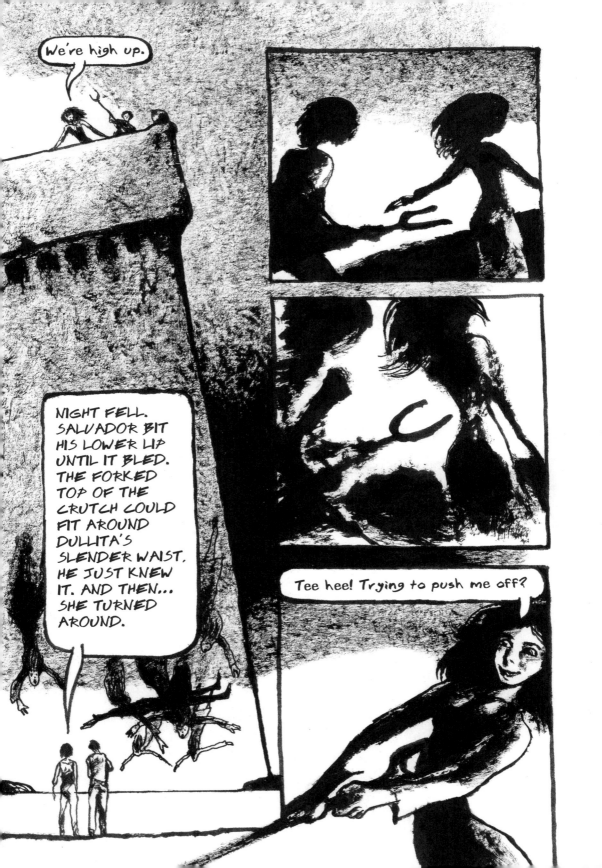

FROM THAT TIME, THE CRUTCH REMAINED, FOR DALÍ, A SYMBOL OF DEATH AND RESURRECTION.

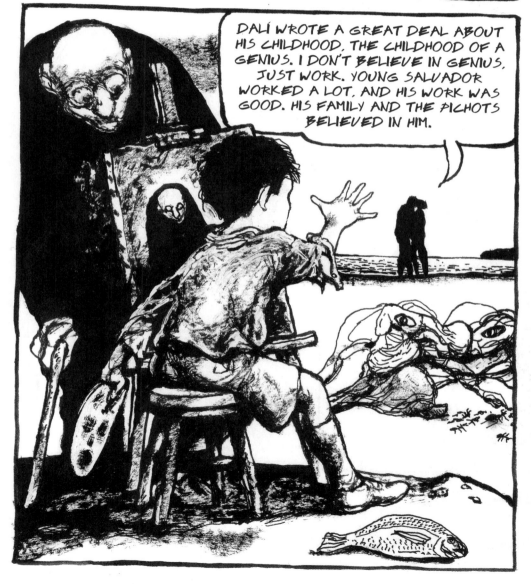

DALÍ WROTE A GREAT DEAL ABOUT HIS CHILDHOOD, THE CHILDHOOD OF A GENIUS. I DON'T BELIEVE IN GENIUS, JUST WORK. YOUNG SALVADOR WORKED A LOT, AND HIS WORK WAS GOOD. HIS FAMILY AND THE PICHOTS BELIEVED IN HIM.

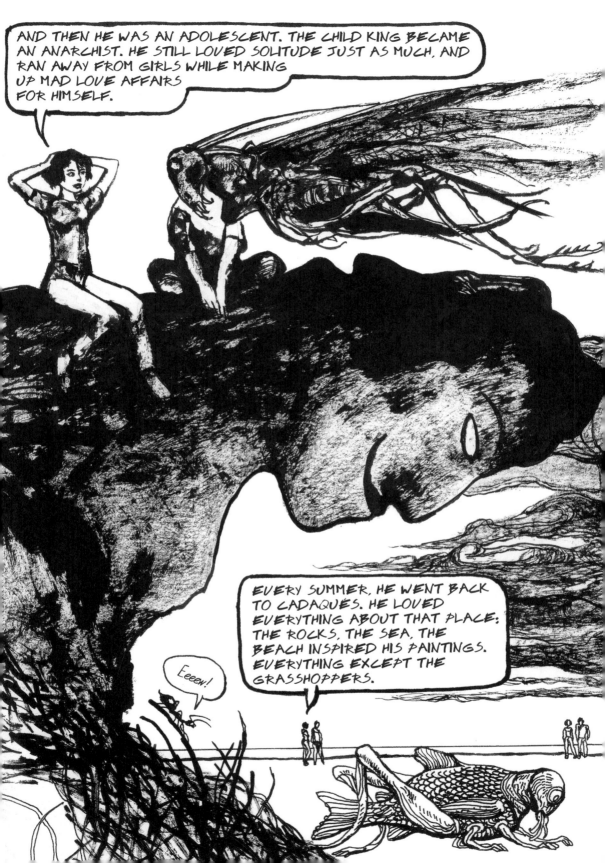

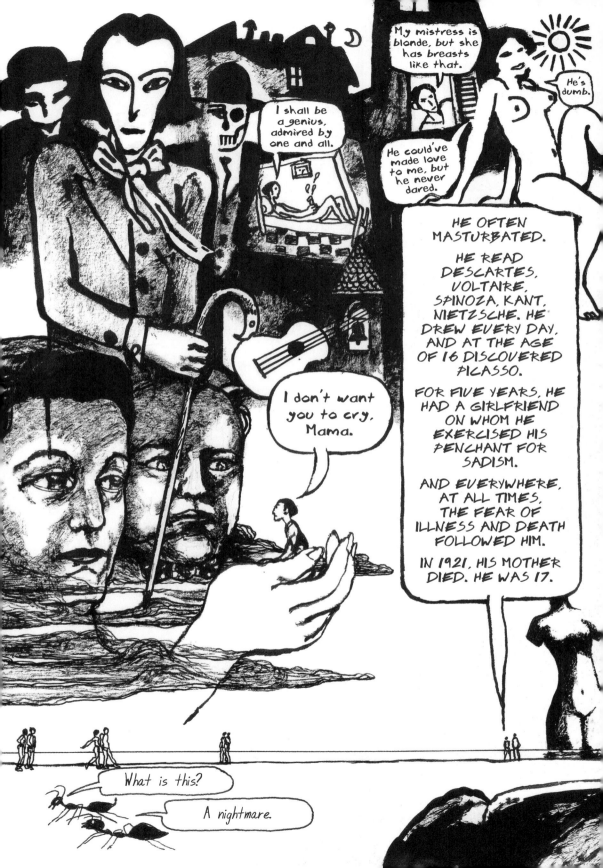

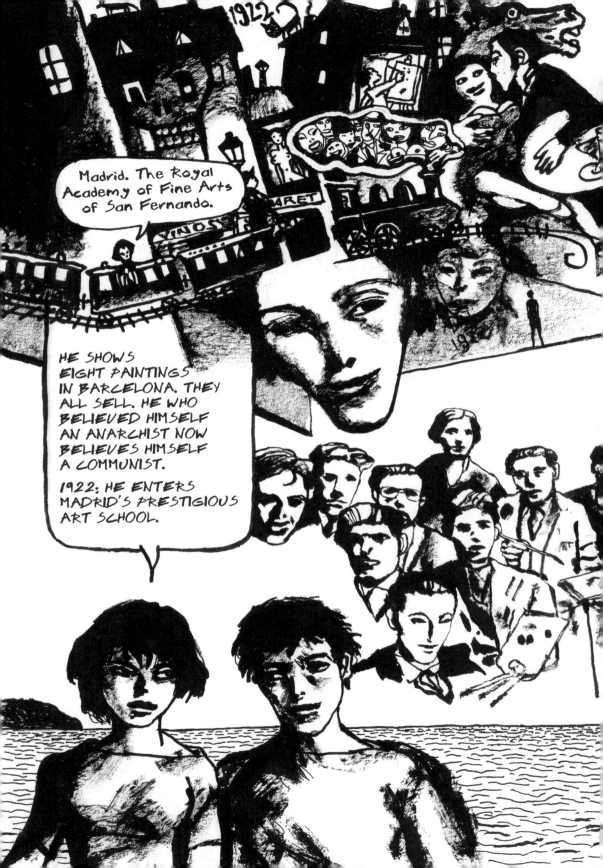

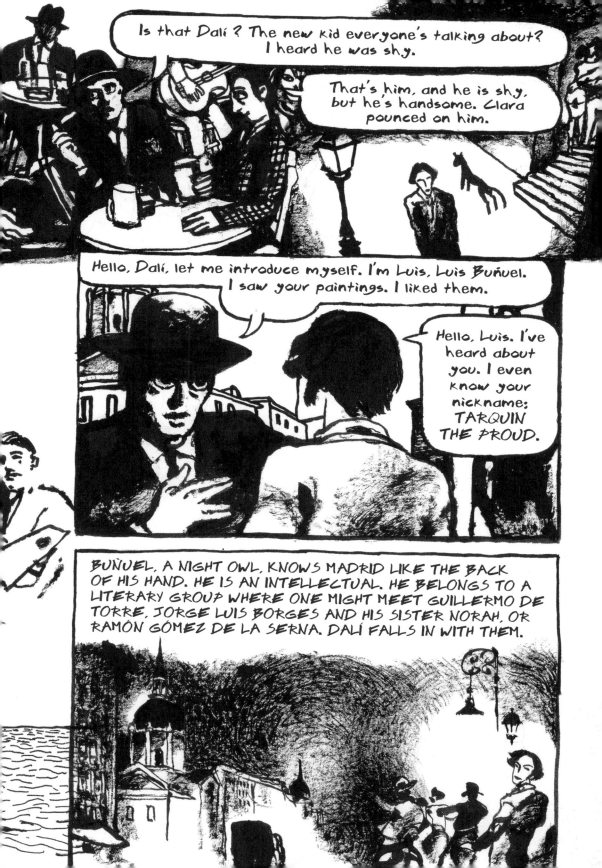

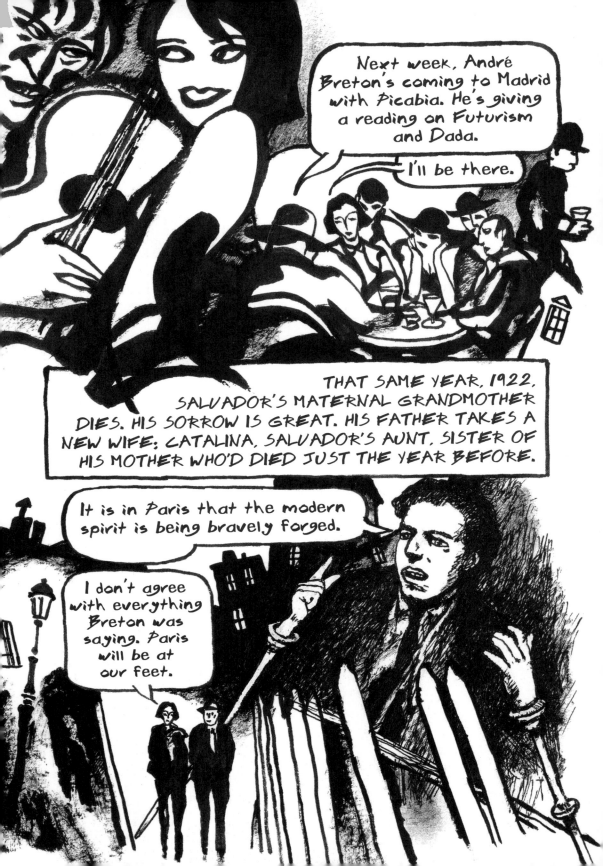

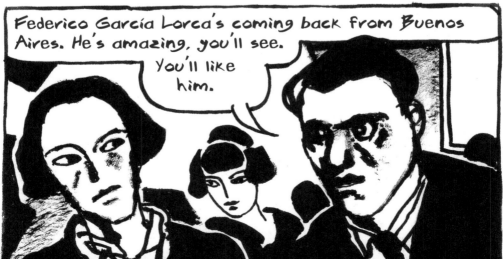

Federico García Lorca's coming back from Buenos Aires. He's amazing, you'll see. You'll like him.

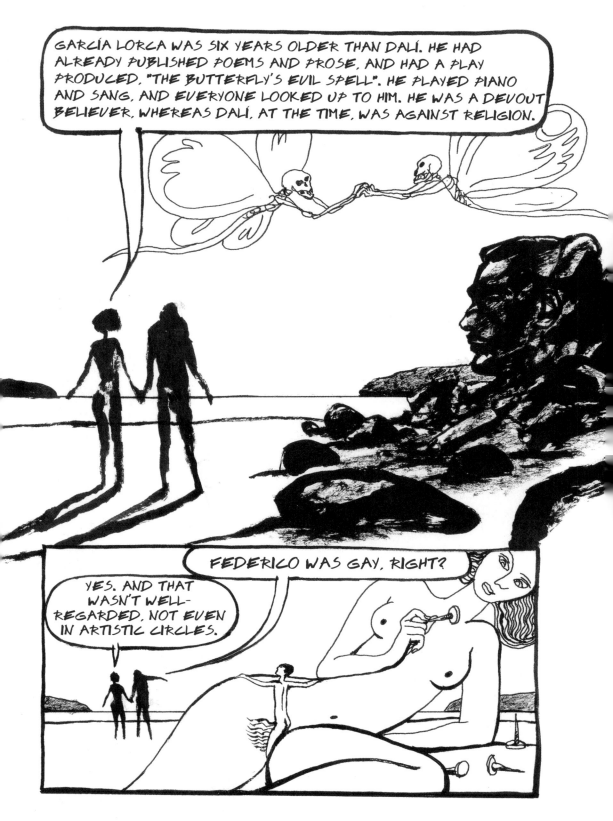

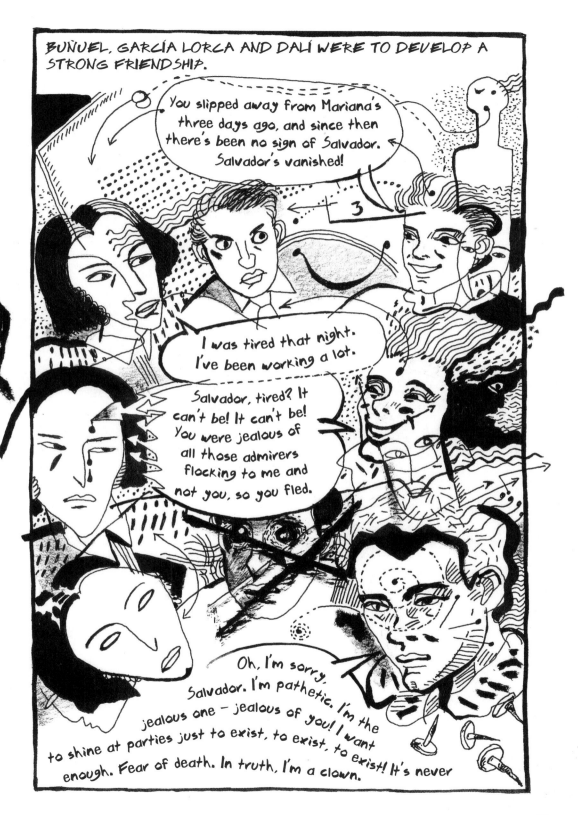

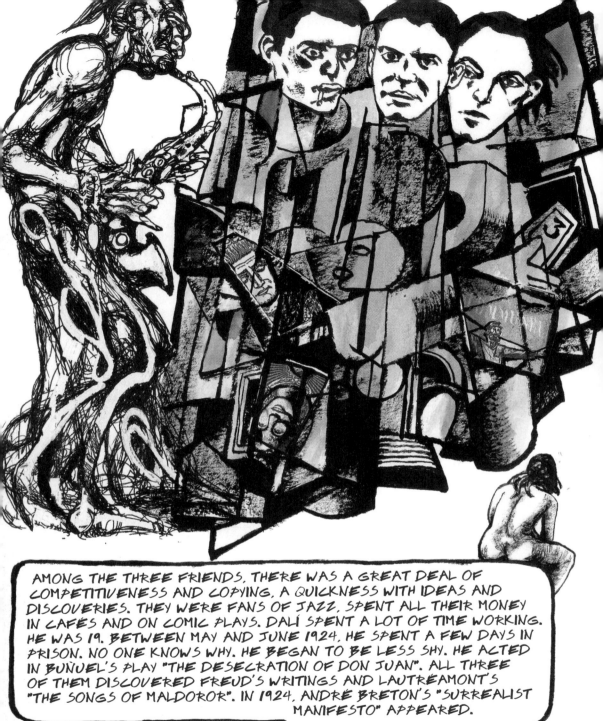

AMONG THE THREE FRIENDS, THERE WAS A GREAT DEAL OF COMPETITIVENESS AND COPYING, A QUICKNESS WITH IDEAS AND DISCOVERIES. THEY WERE FANS OF JAZZ, SPENT ALL THEIR MONEY IN CAFÉS AND ON COMIC PLAYS. DALÍ SPENT A LOT OF TIME WORKING. HE WAS 19. BETWEEN MAY AND JUNE 1924, HE SPENT A FEW DAYS IN PRISON. NO ONE KNOWS WHY. HE BEGAN TO BE LESS SHY. HE ACTED IN BUÑUEL'S PLAY "THE DESECRATION OF DON JUAN". ALL THREE OF THEM DISCOVERED FREUD'S WRITINGS AND LAUTRÉAMONT'S "THE SONGS OF MALDOROR". IN 1924, ANDRÉ BRETON'S "SURREALIST MANIFESTO" APPEARED.

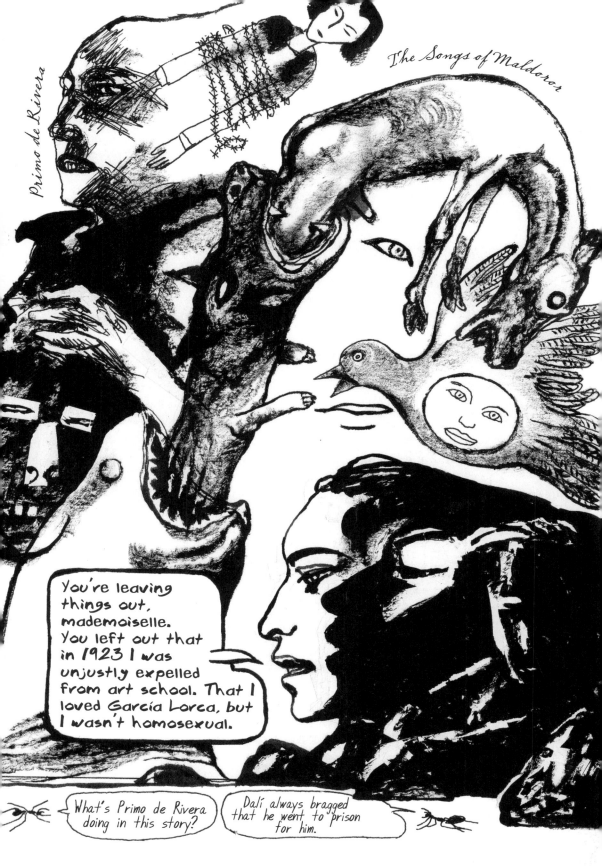

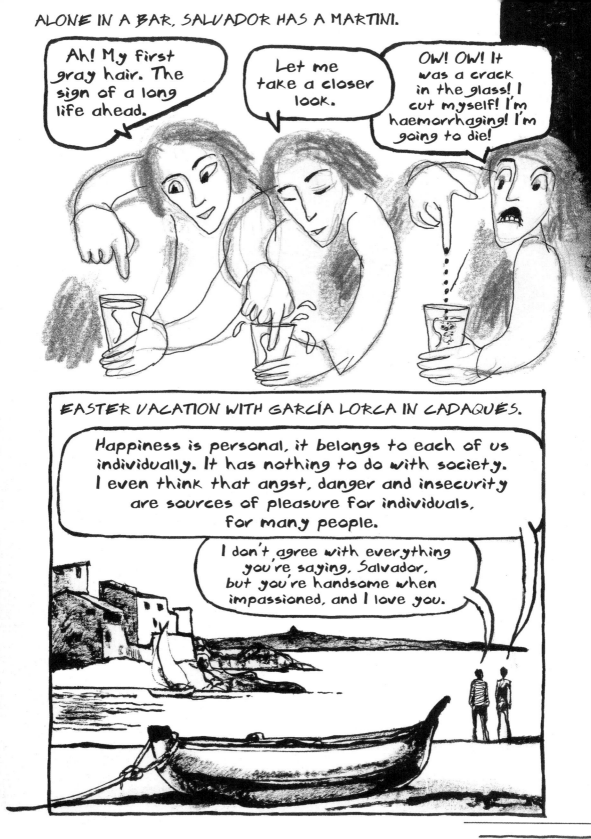

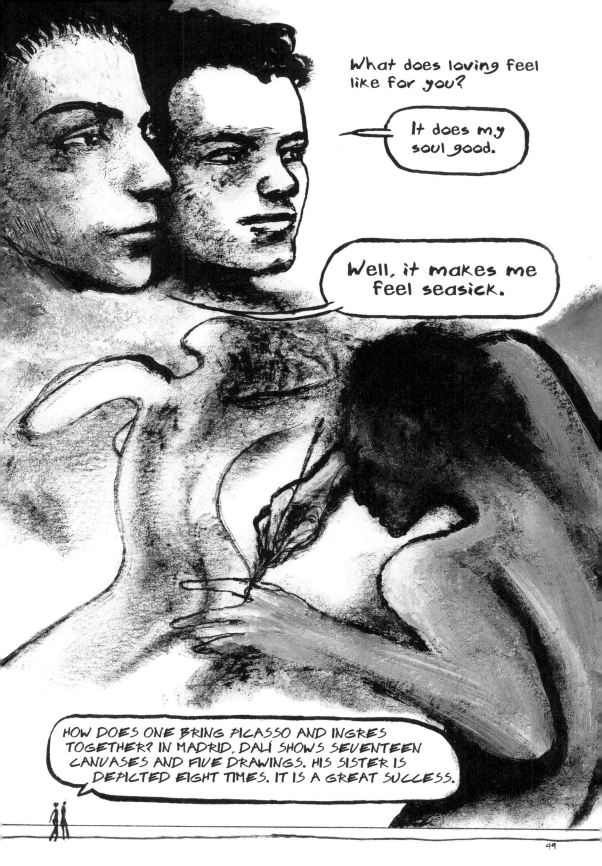

1926: BUÑUEL, WHO IS TAKING HIS FIRST STEPS AS A DIRECTOR, ASKS DALÍ TO COME TO PARIS. DALÍ IS 22. HE HAS A MEETING WITH PICASSO.

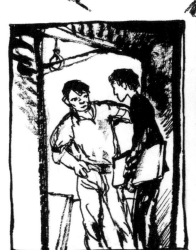

I came to visit you before visiting the Louvre.

And you were right to.

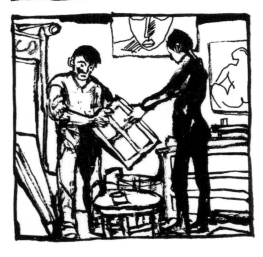

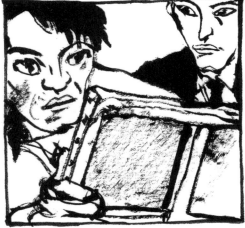

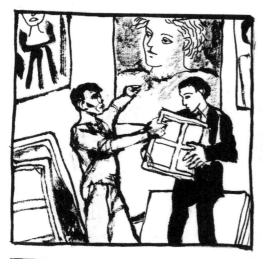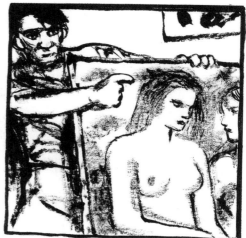

Got it? Got it.

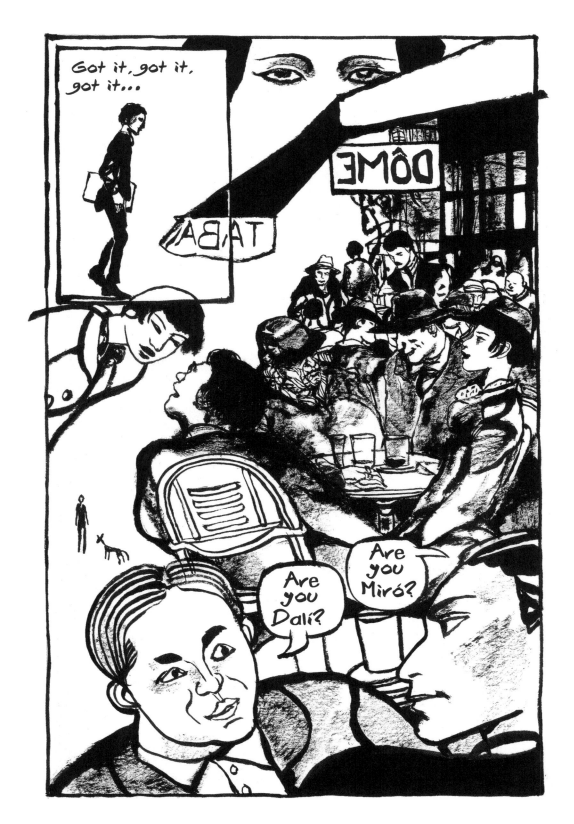

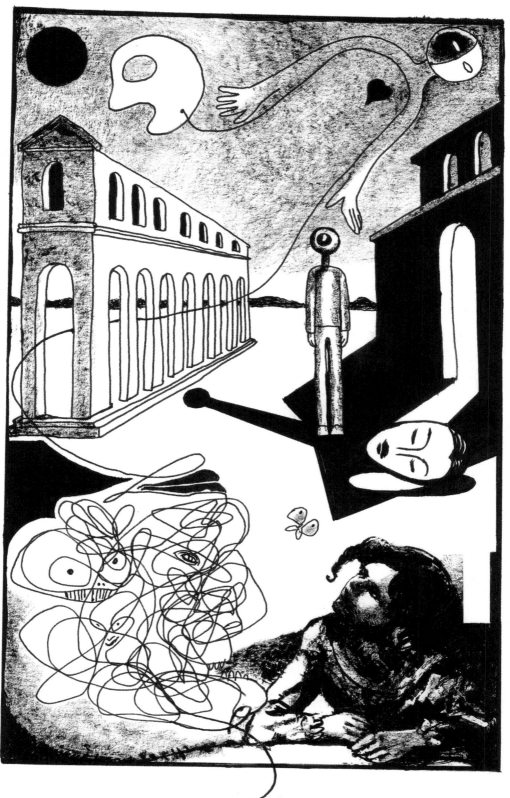

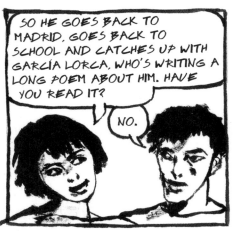

SO HE GOES BACK TO MADRID, GOES BACK TO SCHOOL AND CATCHES UP WITH GARCÍA LORCA, WHO'S WRITING A LONG POEM ABOUT HIM. HAVE YOU READ IT?

NO.

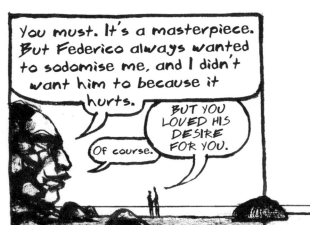

You must. It's a masterpiece. But Federico always wanted to sodomise me, and I didn't want him to because it hurts.

Of course.

BUT YOU LOVED HIS DESIRE FOR YOU.

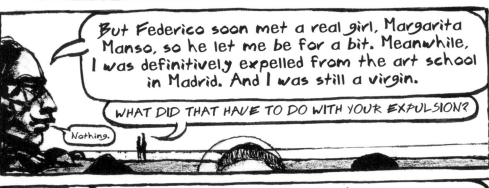

But Federico soon met a real girl, Margarita Manso, so he let me be for a bit. Meanwhile, I was definitively expelled from the art school in Madrid. And I was still a virgin.

WHAT DID THAT HAVE TO DO WITH YOUR EXPULSION?

Nothing.

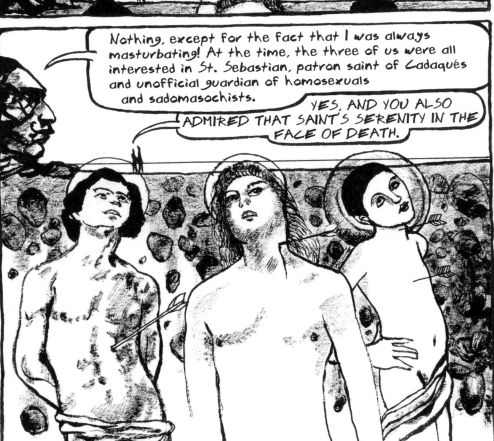

Nothing, except for the fact that I was always masturbating! At the time, the three of us were all interested in St. Sebastian, patron saint of Cadaqués and unofficial guardian of homosexuals and sadomasochists.

YES, AND YOU ALSO ADMIRED THAT SAINT'S SERENITY IN THE FACE OF DEATH.

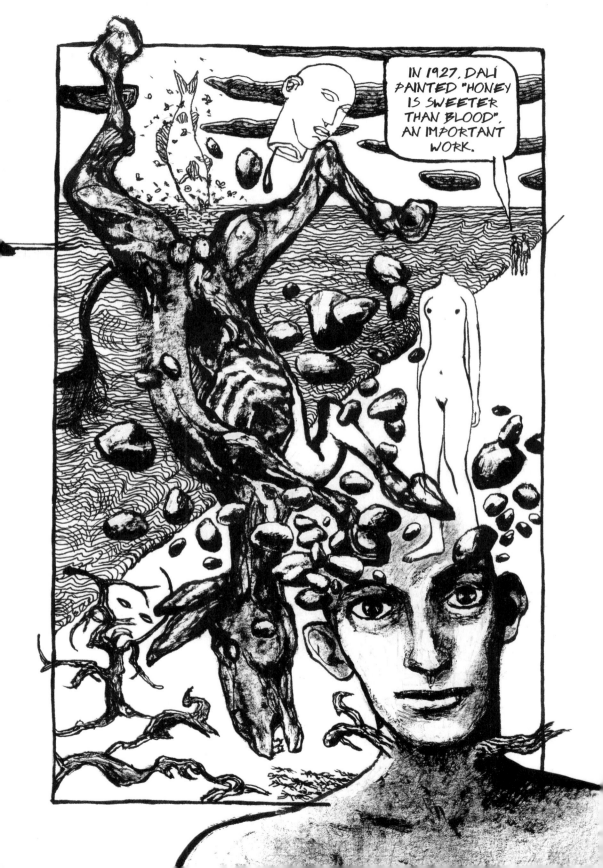

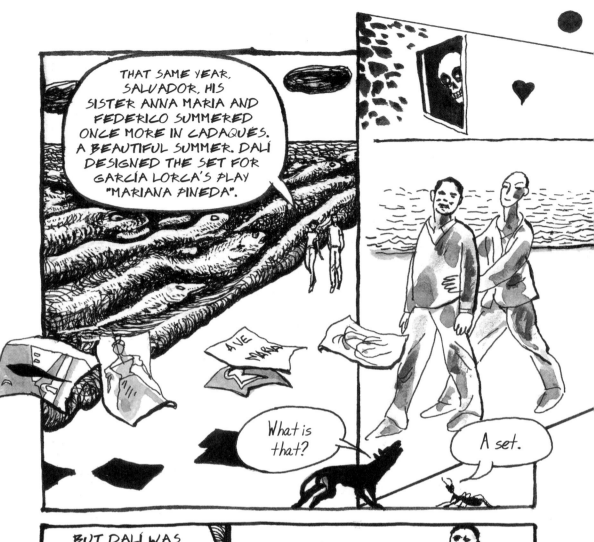

THAT SAME YEAR, SALVADOR, HIS SISTER ANNA MARIA AND FEDERICO SUMMERED ONCE MORE IN CADAQUÉS. A BEAUTIFUL SUMMER. DALÍ DESIGNED THE SET FOR GARCÍA LORCA'S PLAY "MARIANA PINEDA".

What is that?

A set.

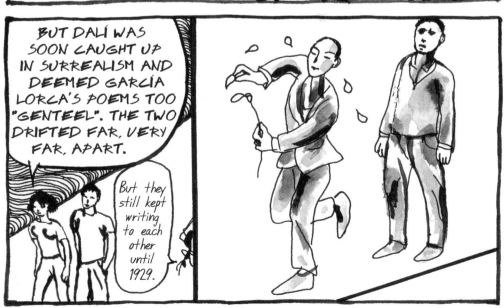

BUT DALÍ WAS SOON CAUGHT UP IN SURREALISM AND DEEMED GARCÍA LORCA'S POEMS TOO "GENTEEL". THE TWO DRIFTED FAR, VERY FAR, APART.

But they still kept writing to each other until 1929.

SUCKED INTO SURREALISM, SUCKED UP BY BUÑUEL. IN SPRING 1929, THEY SHOT "UN CHIEN ANDALOU" TOGETHER.

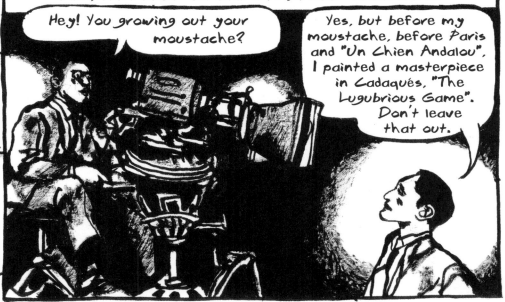

Hey! You growing out your moustache?

Yes, but before my moustache, before Paris and "Un Chien Andalou", I painted a masterpiece in Cadaqués, "The Lugubrious Game". Don't leave that out.

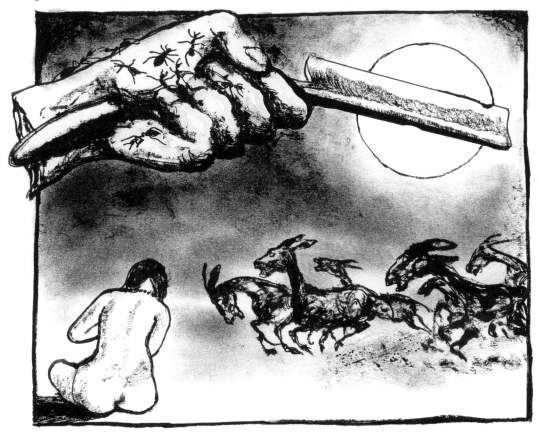

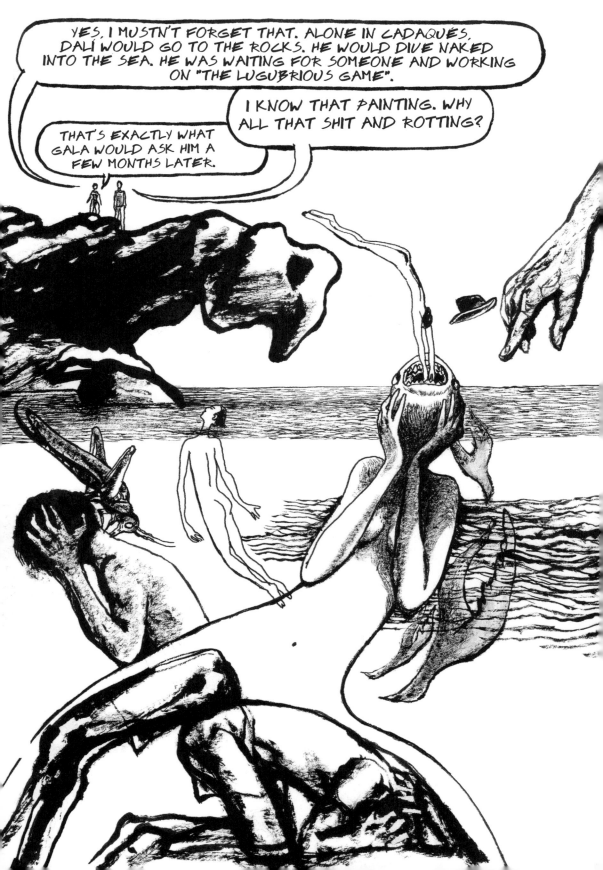

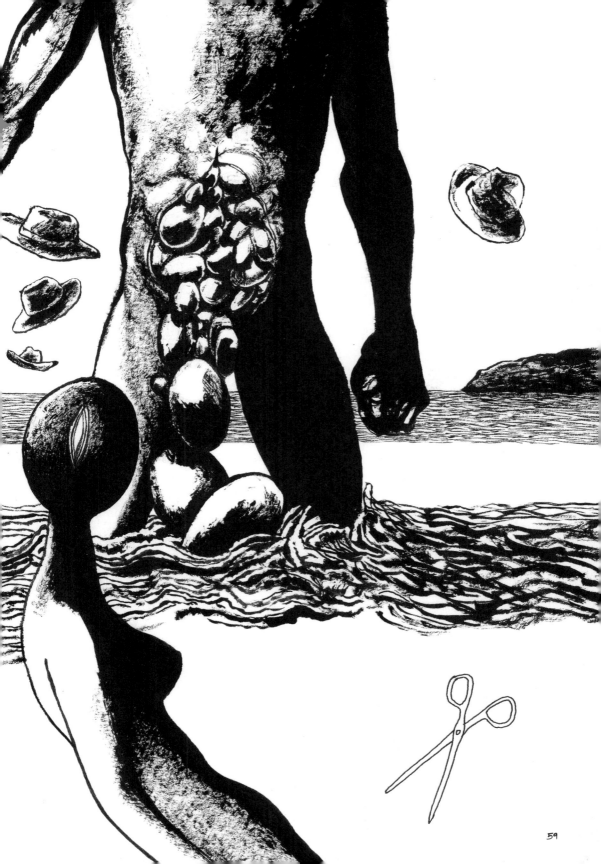

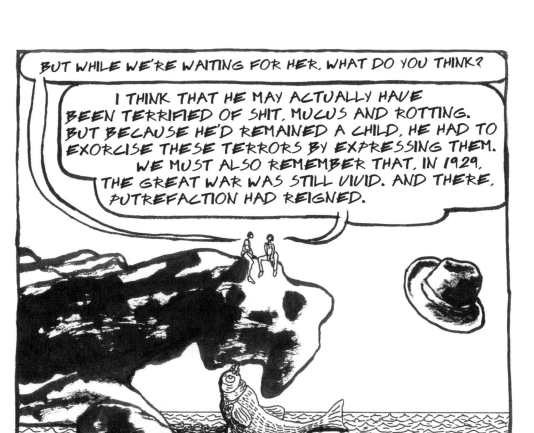

BUT WHILE WE'RE WAITING FOR HER, WHAT DO YOU THINK?

I THINK THAT HE MAY ACTUALLY HAVE BEEN TERRIFIED OF SHIT, MUCUS AND ROTTING. BUT BECAUSE HE'D REMAINED A CHILD, HE HAD TO EXORCISE THESE TERRORS BY EXPRESSING THEM. WE MUST ALSO REMEMBER THAT, IN 1929, THE GREAT WAR WAS STILL VIVID. AND THERE, PUTREFACTION HAD REIGNED.

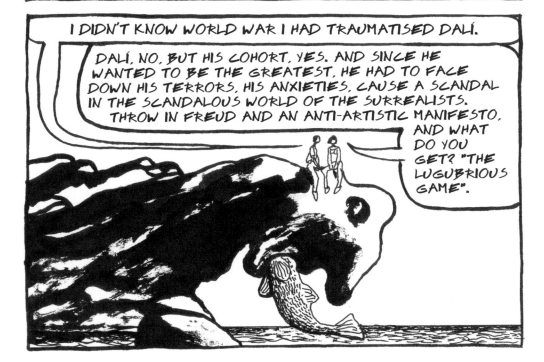

I DIDN'T KNOW WORLD WAR I HAD TRAUMATISED DALÍ.

DALÍ, NO, BUT HIS COHORT, YES. AND SINCE HE WANTED TO BE THE GREATEST, HE HAD TO FACE DOWN HIS TERRORS, HIS ANXIETIES, CAUSE A SCANDAL IN THE SCANDALOUS WORLD OF THE SURREALISTS. THROW IN FREUD AND AN ANTI-ARTISTIC MANIFESTO, AND WHAT DO YOU GET? "THE LUGUBRIOUS GAME".

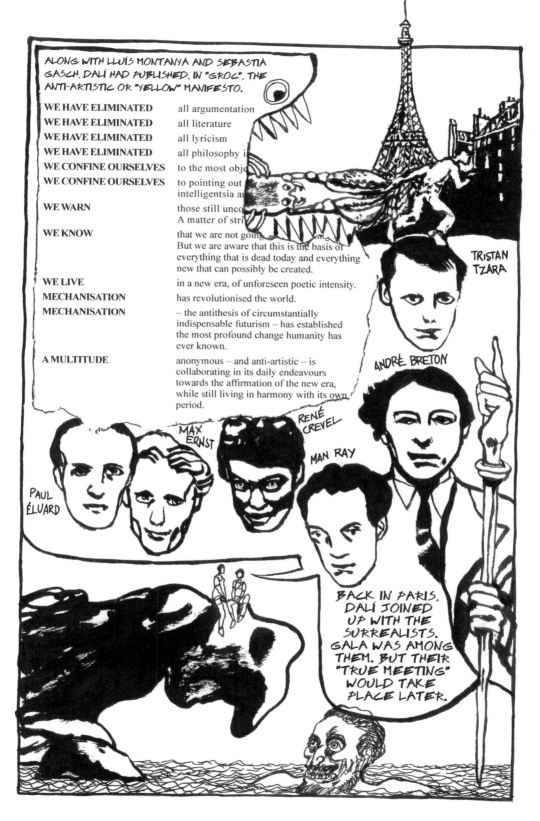

ALONG WITH LLUÍS MONTANYÀ AND SEBASTIÀ GASCH, DALÍ HAD PUBLISHED, IN "GROC", THE ANTI-ARTISTIC OR "YELLOW" MANIFESTO.

WE HAVE ELIMINATED all argumentation
WE HAVE ELIMINATED all literature
WE HAVE ELIMINATED all lyricism
WE HAVE ELIMINATED all philosophy i
WE CONFINE OURSELVES to the most obje
WE CONFINE OURSELVES to pointing out
intelligentsia a
WE WARN those still unco
A matter of stri
WE KNOW that we are not goin
But we are aware that this is the basis of everything that is dead today and everything new that can possibly be created.

WE LIVE in a new era, of unforeseen poetic intensity.
MECHANISATION has revolutionised the world.
MECHANISATION – the antithesis of circumstantially indispensable futurism – has established the most profound change humanity has ever known.

A MULTITUDE anonymous – and anti-artistic – is collaborating in its daily endeavours towards the affirmation of the new era, while still living in harmony with its own period.

TRISTAN TZARA

ANDRÉ BRETON

RENÉ CREVEL

MAX ERNST

MAN RAY

PAUL ÉLUARD

BACK IN PARIS, DALÍ JOINED UP WITH THE SURREALISTS. GALA WAS AMONG THEM. BUT THEIR "TRUE MEETING" WOULD TAKE PLACE LATER.

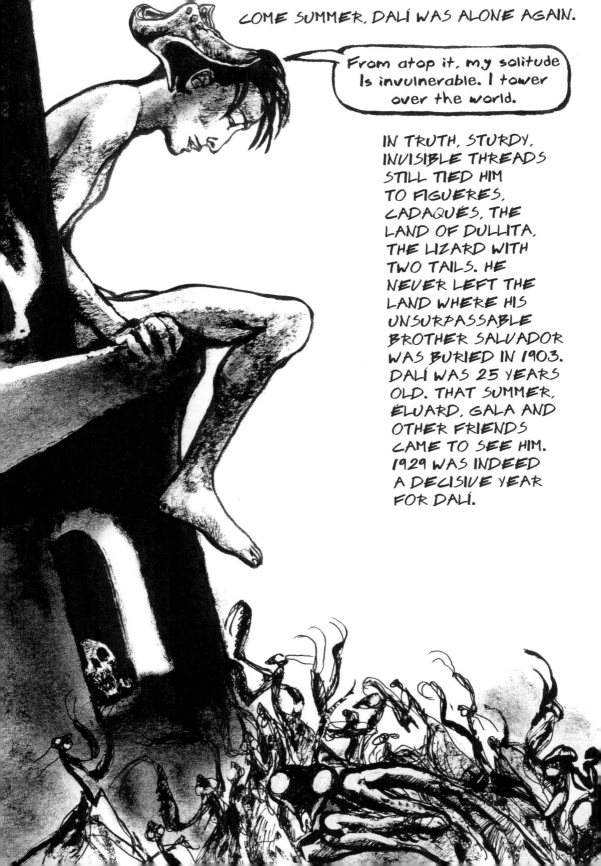

COME SUMMER, DALÍ WAS ALONE AGAIN.

From atop it, my solitude is invulnerable. I tower over the world.

IN TRUTH, STURDY, INVISIBLE THREADS STILL TIED HIM TO FIGUERES, CADAQUES, THE LAND OF DULLITA, THE LIZARD WITH TWO TAILS. HE NEVER LEFT THE LAND WHERE HIS UNSURPASSABLE BROTHER SALVADOR WAS BURIED IN 1903. DALÍ WAS 25 YEARS OLD. THAT SUMMER, ÉLUARD, GALA AND OTHER FRIENDS CAME TO SEE HIM. 1929 WAS INDEED A DECISIVE YEAR FOR DALÍ.

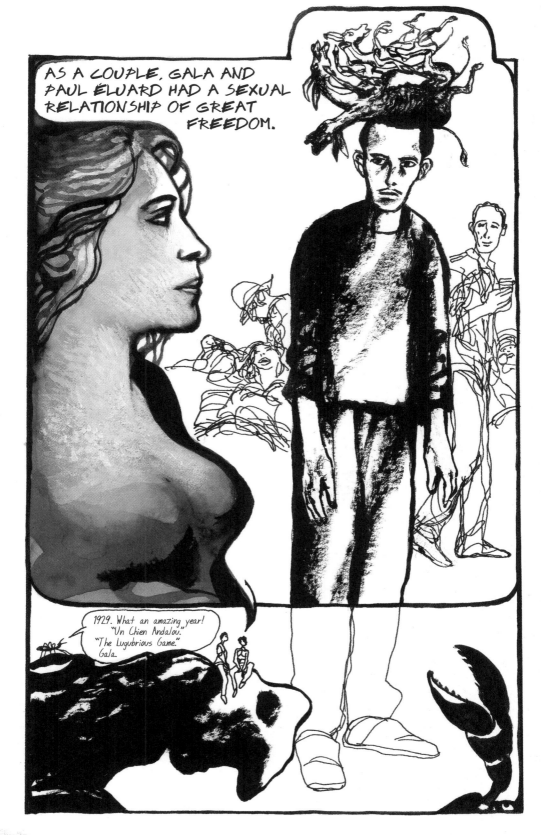

AS A COUPLE, GALA AND PAUL ÉLUARD HAD A SEXUAL RELATIONSHIP OF GREAT FREEDOM.

1929. What an amazing year!
"Un Chien Andalou."
"The Lugubrious Game."
Gala.

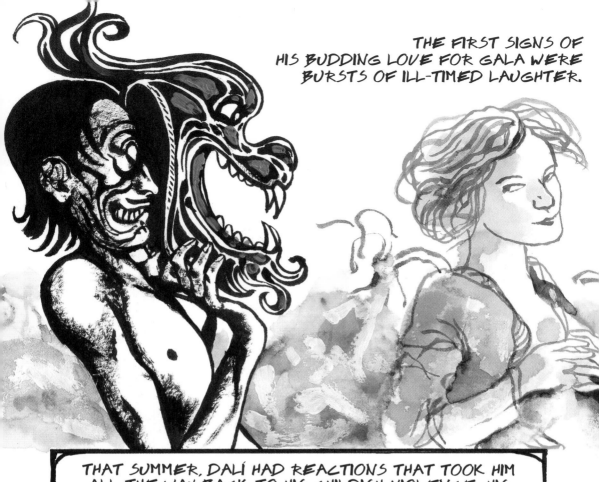

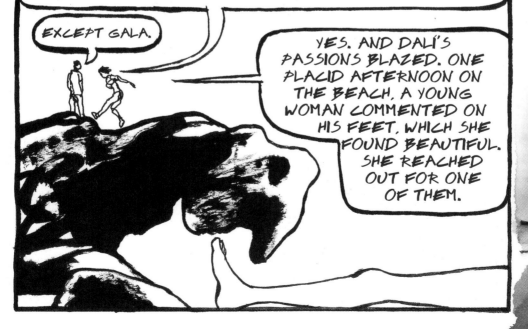

THAT SUMMER, DALÍ HAD REACTIONS THAT TOOK HIM ALL THE WAY BACK TO HIS CHILDISH VIOLENCE. HIS BEHAVIOUR THREW HIS GUESTS INTO CONFUSION.

EXCEPT GALA.

YES. AND DALÍ'S PASSIONS BLAZED. ONE PLACID AFTERNOON ON THE BEACH, A YOUNG WOMAN COMMENTED ON HIS FEET, WHICH SHE FOUND BEAUTIFUL. SHE REACHED OUT FOR ONE OF THEM.

AT THIS, DALÍ LEAPT UP. SEIZED WITH JEALOUSY OVER HIMSELF, AS IF HE HAD BECOME GALA, HE BEGAN TRAMPLING THE WOMAN WITH ALL HIS MIGHT. THEY HAD TO PULL HIM OFF HER AND CALM HIM DOWN. BUT WHO WAS HE TRAMPLING? HIS LITTLE SISTER? HIS BROTHER? HIMSELF?

Is that true?

Dalí relates it in his book "The Secret Life of Salvador Dalí".

Will you take me for a walk out among the rocks?

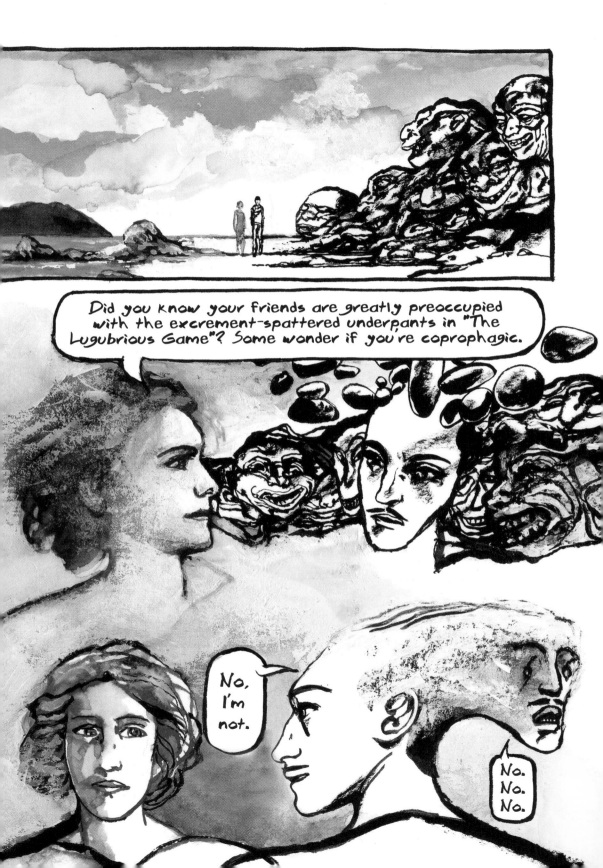

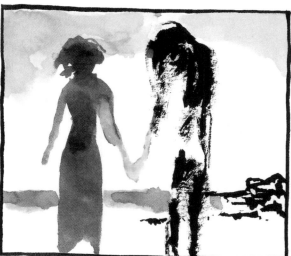

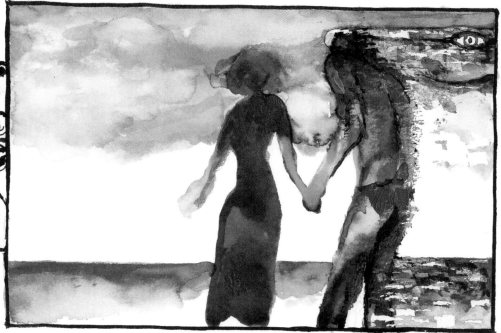

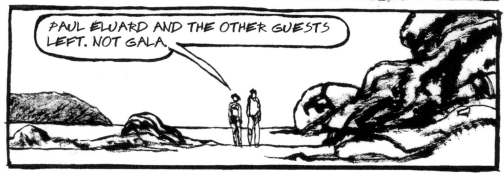

PAUL ÉLUARD AND THE OTHER GUESTS LEFT. NOT GALA.

FROM CADAQUÉS TO PARIS. BUÑUEL AND DALÍ PRESENT "UN CHIEN ANDALOU" AT STUDIO 28. THE FILM IS A SUCCESS, A SCANDAL. IT PROVOKES IMPASSIONED REACTIONS IN THE PRESS. THE SURREALISTS OPEN THEIR DOOR TO THEM.

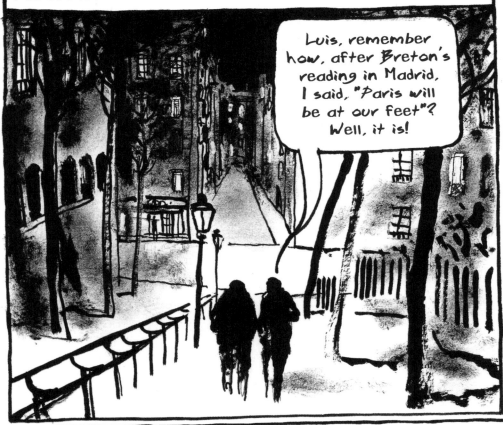

Luis, remember how, after Breton's reading in Madrid, I said, "Paris will be at our feet"? Well, it is!

IN NOVEMBER, DALÍ HAS A SHOW AT THE GALERIE GOEMANS IN PARIS. AMONG THE WORKS ON DISPLAY IS ONE THAT SAYS, "SOMETIMES I SPIT WITH PLEASURE ON THE PORTRAIT OF MY MOTHER." THIS PROVOCATION, AND HIS AFFAIR WITH GALA, WILL CAUSE A FALLING OUT WITH HIS FATHER. THE TWO WILL NOT RECONCILE UNTIL 1948.

SPIT ON HIS MOTHER'S PORTRAIT?

FOR SALVADOR DALÍ, SPITTING WAS AN ACT OF LOVE.

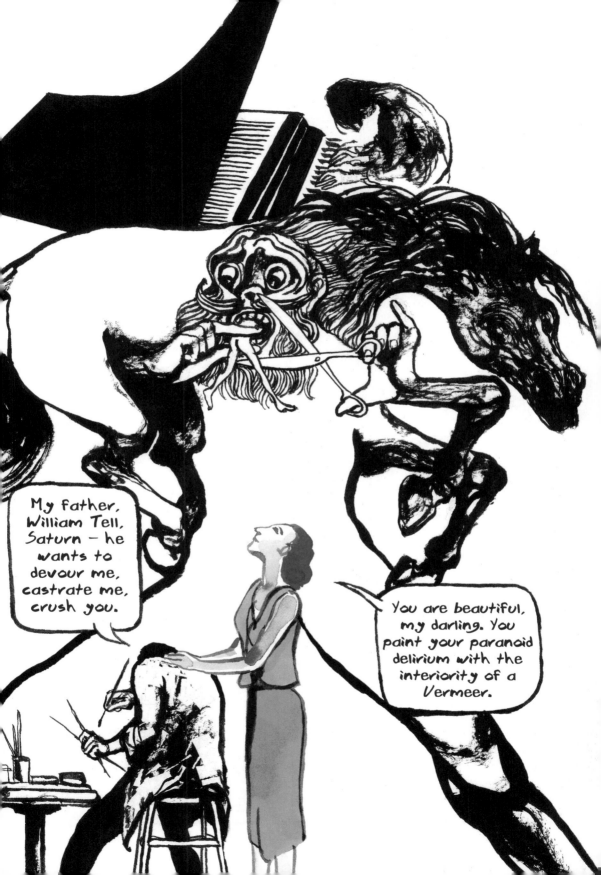

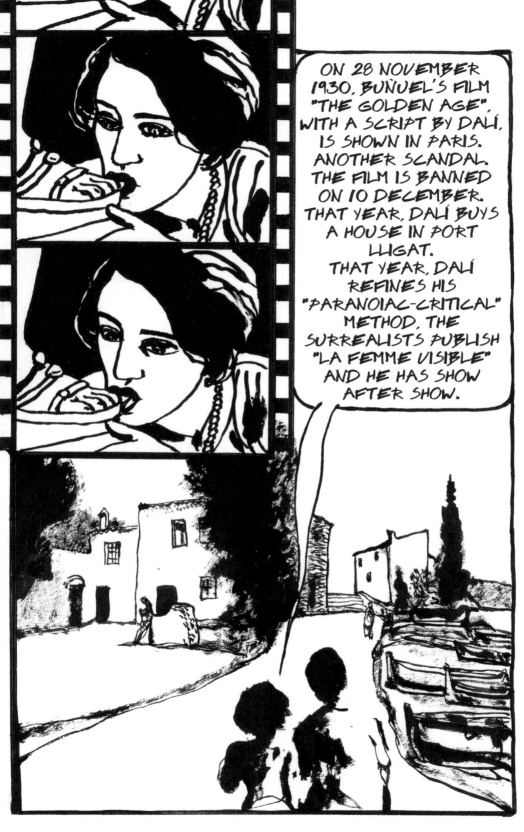

ON 28 NOVEMBER 1930, BUÑUEL'S FILM "THE GOLDEN AGE", WITH A SCRIPT BY DALÍ, IS SHOWN IN PARIS. ANOTHER SCANDAL. THE FILM IS BANNED ON 10 DECEMBER. THAT YEAR, DALÍ BUYS A HOUSE IN PORT LLIGAT.
THAT YEAR, DALÍ REFINES HIS "PARANOIAC-CRITICAL" METHOD, THE SURREALISTS PUBLISH "LA FEMME VISIBLE" AND HE HAS SHOW AFTER SHOW.

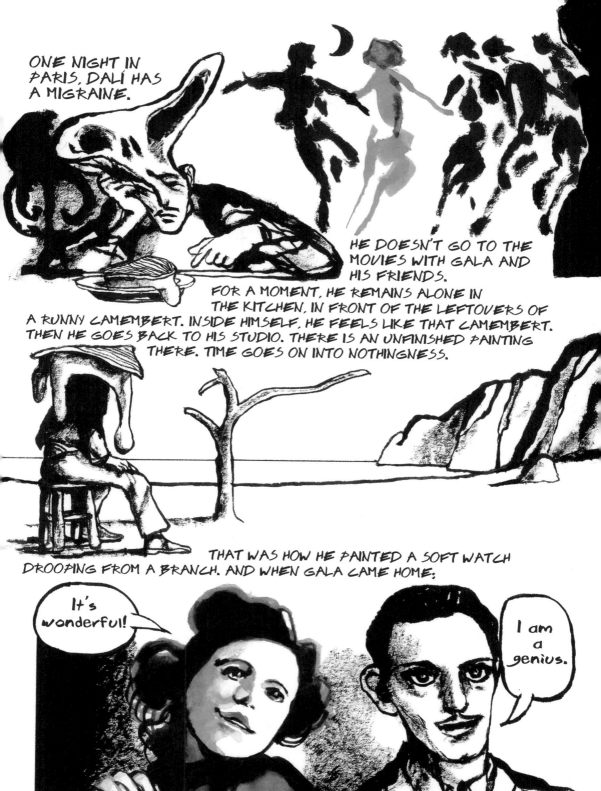

ONE NIGHT IN PARIS, DALÍ HAS A MIGRAINE.

HE DOESN'T GO TO THE MOVIES WITH GALA AND HIS FRIENDS.

FOR A MOMENT, HE REMAINS ALONE IN THE KITCHEN, IN FRONT OF THE LEFTOVERS OF A RUNNY CAMEMBERT. INSIDE HIMSELF, HE FEELS LIKE THAT CAMEMBERT. THEN HE GOES BACK TO HIS STUDIO. THERE IS AN UNFINISHED PAINTING THERE. TIME GOES ON INTO NOTHINGNESS.

THAT WAS HOW HE PAINTED A SOFT WATCH DROOPING FROM A BRANCH. AND WHEN GALA CAME HOME:

It's wonderful!

I am a genius.

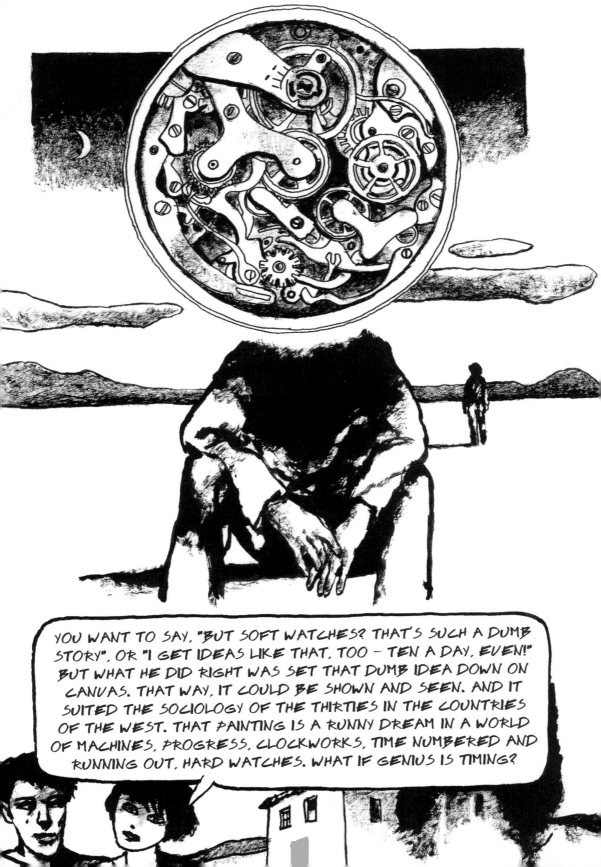

THIS IS DALÍ'S HOUSE. IT DIDN'T LOOK LIKE THIS WHEN HE BOUGHT IT. HE WAS STILL A YOUNG REBEL AND NOT YET RICH.

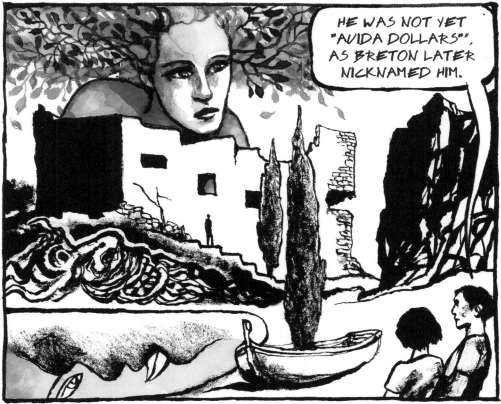

HE WAS NOT YET "AVIDA DOLLARS"*, AS BRETON LATER NICKNAMED HIM.

* AN ANAGRAM OF "SALVADOR DALÍ", WHICH ROUGHLY TRANSLATES AS "GREEDY FOR DOLLARS".

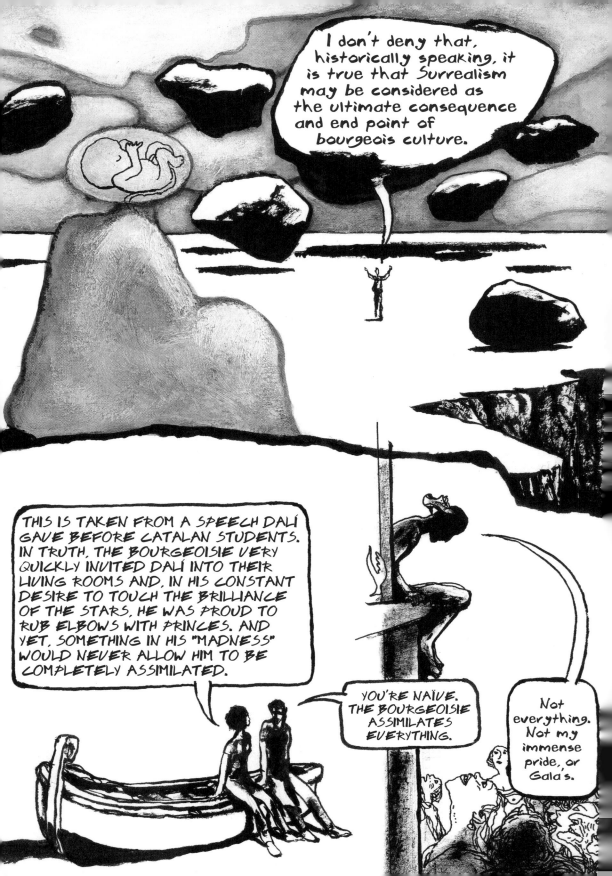

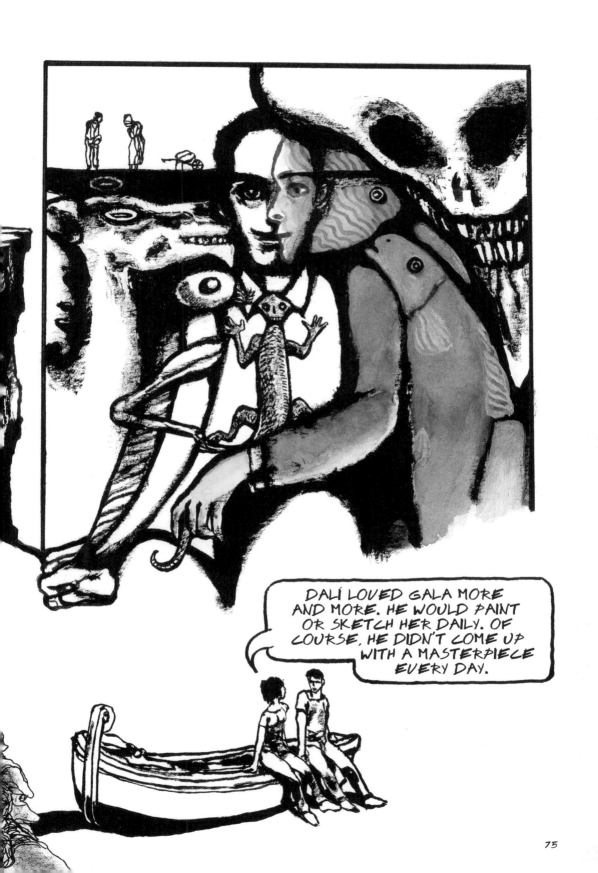

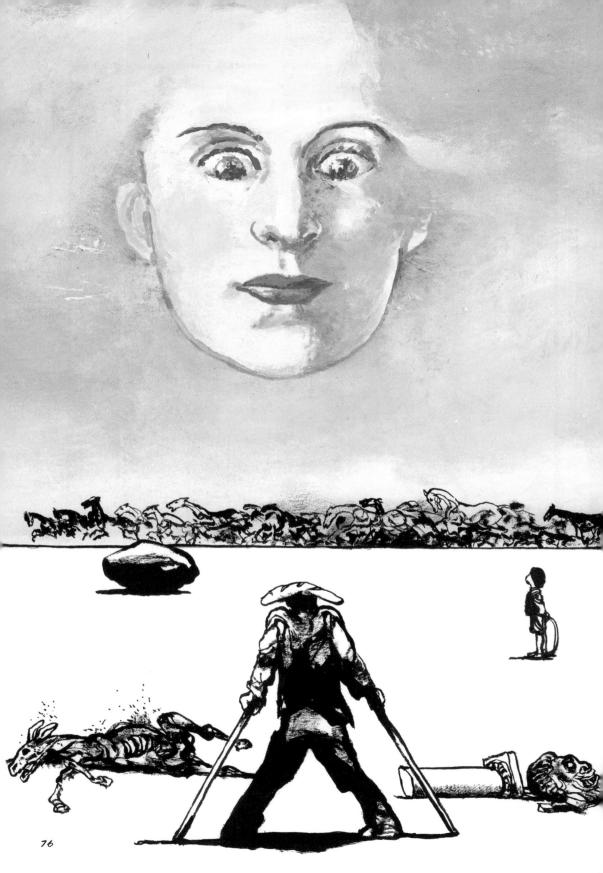

IN OCTOBER 1934, THERE IS AN ANARCHIST INSURRECTION IN CATALONIA. IN NOVEMBER, GALA AND DALÍ ARE ABOARD THE CHAMPLAIN, HEADING FOR AMERICA. IT IS A JOURNEY LONG IN THE MAKING.

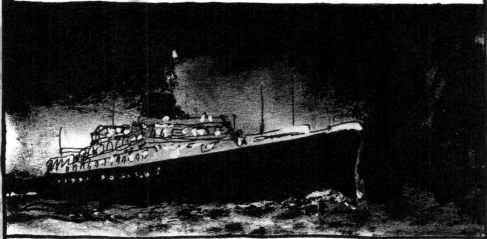

SALVADOR SPENDS THE CROSSING IN HIS CABIN, ATTACHED TO HIS CANVASES BY STRING TIED TO HIS FINGERS, HIS CLOTHES.

AT ONE POINT, GALA MUST HAVE MANAGED TO LURE HIM UP ON DECK.

HE IS PHOTOGRAPHED. IN THIS PHOTO, I SEE HIS FRAGILITY, THE EXCITEMENT OF A CHILD BEFORE A GREAT PARTY, A DISCOVERY TO COME, EXALTATION.

I ALSO SEE FATIGUE, FEAR OF NOT MAKING IT AND THE DESIRE TO HASTEN, AFTER THE PHOTO SESSION, BACK TO HIS CABIN AND HIS CANVASES.

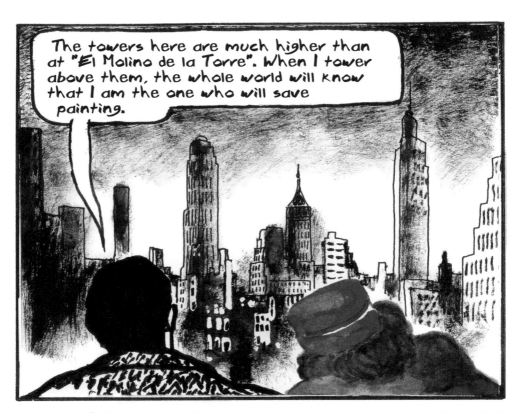

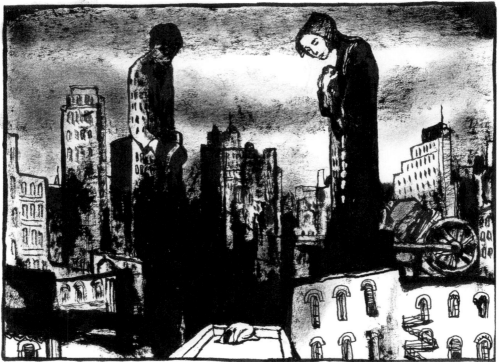

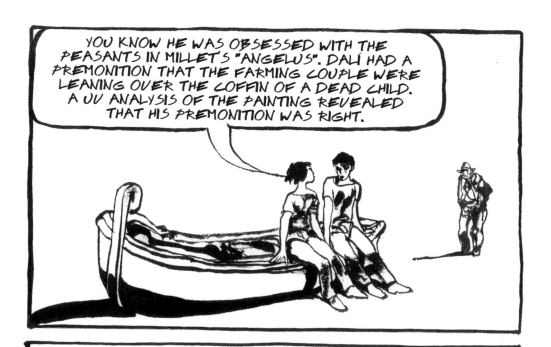

THIS FIRST TRIP TO NEW YORK, WHICH DALÍ HAD PREPARED FOR AS A PERSONAL CONQUEST OF AMERICA, WAS A SUCCESS: LECTURES, EXHIBITIONS, ADORATION.

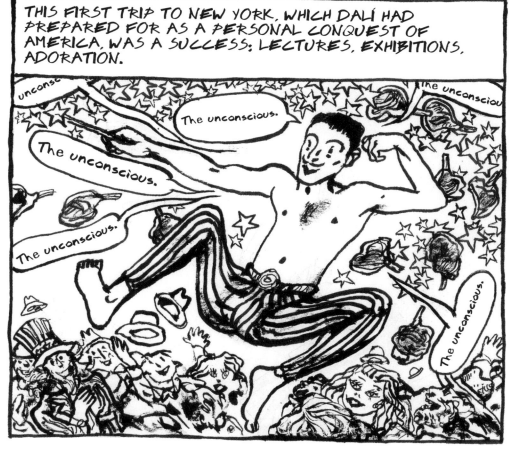

FEBRUARY 1935: RETURN TO EUROPE. DALÍ PAINTS "PREMONITION OF CIVIL WAR". ON 1 JULY 1936, DALÍ IS IN LONDON GIVING A LECTURE, WEARING A DIVING HELMET TO SHOW THAT HIS WORK DIVES INTO THE UNCONSCIOUS. HE ALMOST SUFFOCATES TO DEATH. ON 18 JULY, CIVIL WAR BREAKS OUT IN SPAIN.

After
Goya
+ Buñuel
+ Lorca
+ Dalí

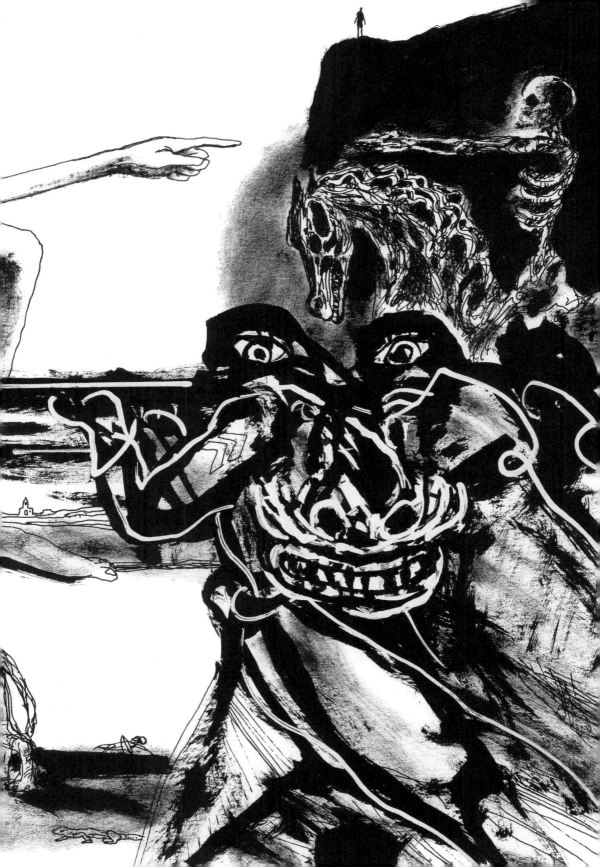

FEDERICO GARCÍA LORCA DIES BY FIRING SQUAD ON 19 AUGUST 1936. UPON HEARING THE NEWS, DALÍ EXCLAIMS, "OLÉ!", AN EXCLAMATION OF ADMIRATION USED TO HAIL A PARTICULARLY DARING PASS IN BULLFIGHTING. IN HIS EYES, GARCÍA LORCA, WHO WAS EQUALLY OBSESSED WITH DEATH, HAD THUS ATTAINED THE FULLEST PERFECTION OF HIS LIFE. LORCA'S DEATH WILL CHANGE DALÍ FOREVER.

ON 7 DECEMBER, GALA AND DALÍ RETURN TO NEW YORK. HE IS ON THE COVER OF "TIME".

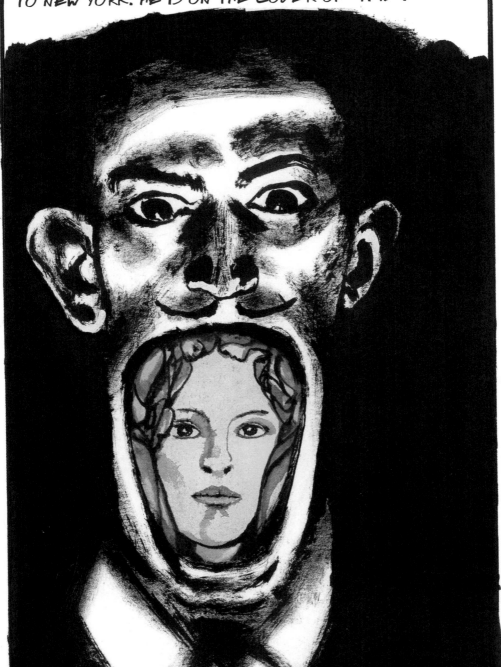

IN FEBRUARY 1937, DALÍ IS IN HOLLYWOOD, WHERE HE PAINTS A PORTRAIT OF HARPO MARX. IN APRIL, HE AND GALA ARE ON THE SLOPES IN SWITZERLAND AND AUSTRIA.

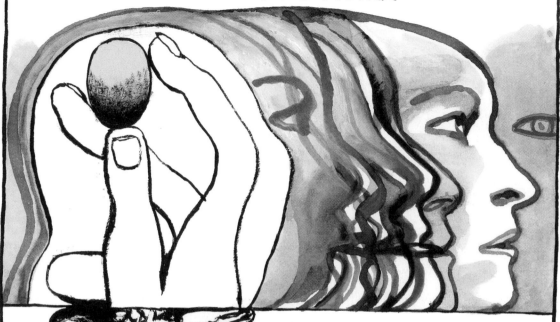

THAT YEAR, HE PAINTS "METAMORPHOSIS OF NARCISSUS", THAT PAINTING YOU LIKE. HE WROTE A POEM TO GO WITH IT. HE ENDS WITH THE EXPECTATION THAT THE EGG, THAT HEAD, WILL BREAK, BURST OPEN, AND A FLOWER, A NEW NARCISSUS, WILL BLOOM, AND IT WILL BE GALA, "MY NARCISSUS".
JACQUES LACAN WILL BE VERY INTERESTED IN DALÍ'S APPROACH TO DREAMS AND HALLUCINATIONS – WHAT DALÍ CALLS HIS "PARANOIAC" METHOD.

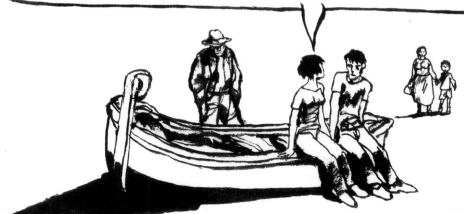

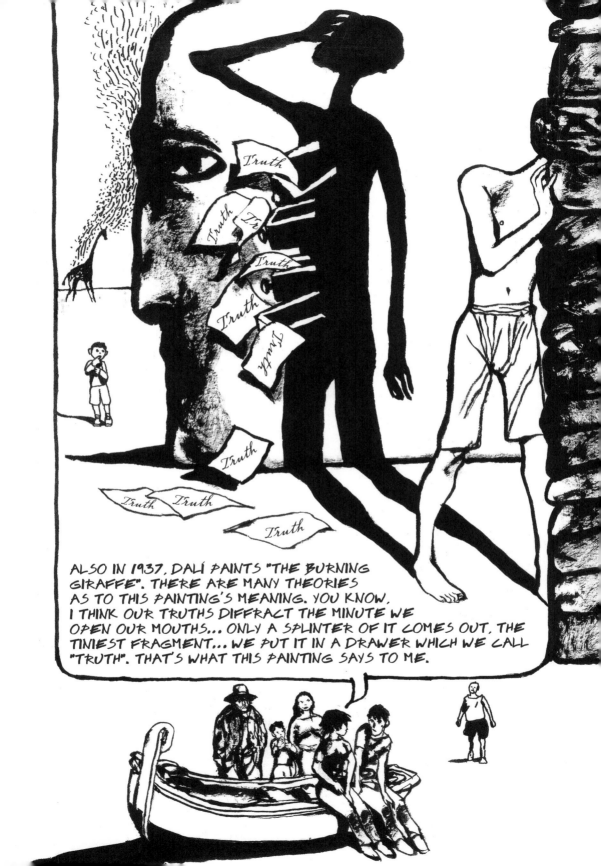

ALSO IN 1937, DALÍ PAINTS "THE BURNING GIRAFFE". THERE ARE MANY THEORIES AS TO THIS PAINTING'S MEANING. YOU KNOW, I THINK OUR TRUTHS DIFFRACT THE MINUTE WE OPEN OUR MOUTHS... ONLY A SPLINTER OF IT COMES OUT, THE TINIEST FRAGMENT... WE PUT IT IN A DRAWER WHICH WE CALL "TRUTH". THAT'S WHAT THIS PAINTING SAYS TO ME.

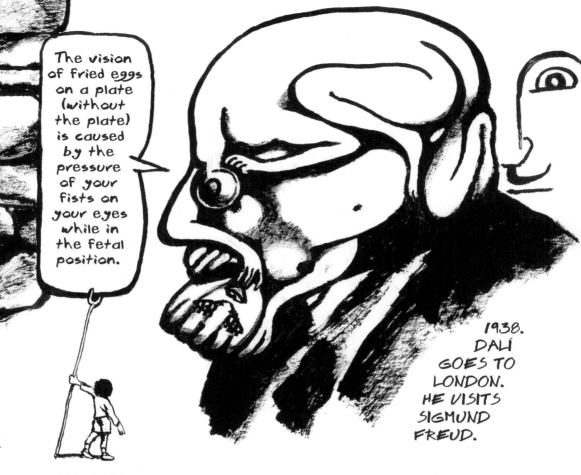

The vision of fried eggs on a plate (without the plate) is caused by the pressure of your fists on your eyes while in the fetal position.

1938. DALÍ GOES TO LONDON. HE VISITS SIGMUND FREUD.

MORE AND MORE OFTEN, HE IS FOUND IN SALONS WITH GILDED MOULDING. HE IS FREQUENTLY SEEN AT COCO CHANEL'S.

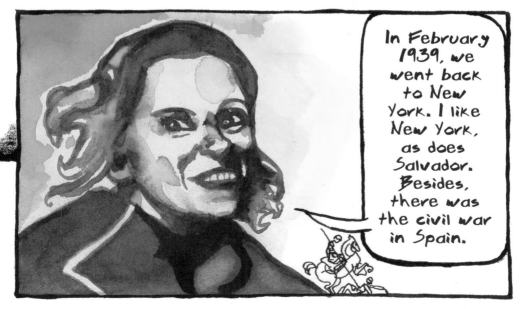

In February 1939, we went back to New York. I like New York, as does Salvador. Besides, there was the civil war in Spain.

WHEN HE ARRIVED, BONWIT TELLER, A HIGH-END FIFTH AVENUE DEPARTMENT STORE, REACHED OUT TO ASK HIM IF HE'D DRESS THEIR WINDOWS. DALI SAID YES, BUT UNDER ONE CONDITION: COMPLETE CARTE BLANCHE.

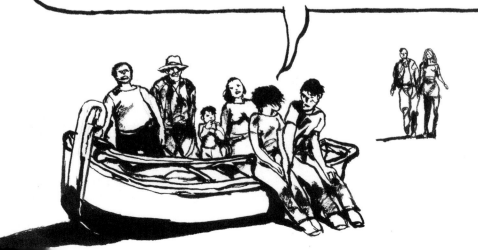

We'll put the old mannequins from 1900 that we found in the attic over here. I said, "Whatever you do, don't dust them off or clean up the cobwebs." Let's put the fleece-lined *bathtub* full of *water* over here, and the **canopy bed** with its *buffalo* head and feet over there, and the *bloody* pigeon in its jaws.

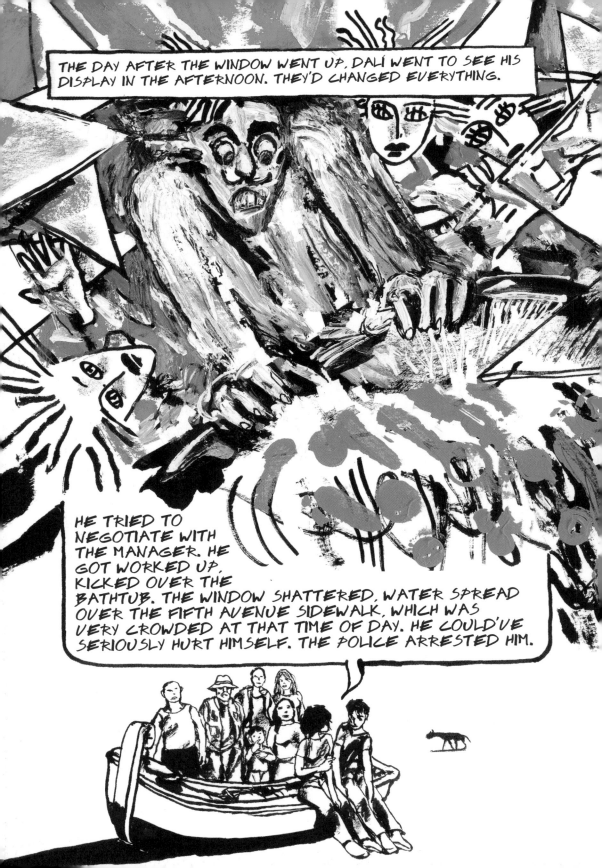

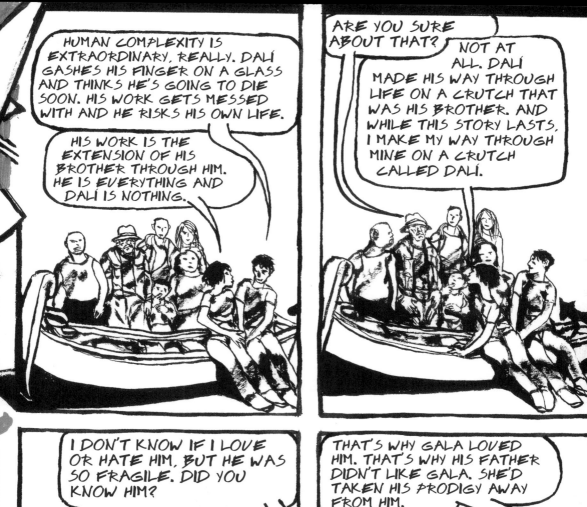

HUMAN COMPLEXITY IS EXTRAORDINARY, REALLY. DALÍ GASHES HIS FINGER ON A GLASS AND THINKS HE'S GOING TO DIE SOON. HIS WORK GETS MESSED WITH AND HE RISKS HIS OWN LIFE.

HIS WORK IS THE EXTENSION OF HIS BROTHER THROUGH HIM. HE IS EVERYTHING AND DALÍ IS NOTHING.

ARE YOU SURE ABOUT THAT?

NOT AT ALL. DALÍ MADE HIS WAY THROUGH LIFE ON A CRUTCH THAT WAS HIS BROTHER. AND WHILE THIS STORY LASTS, I MAKE MY WAY THROUGH MINE ON A CRUTCH CALLED DALÍ.

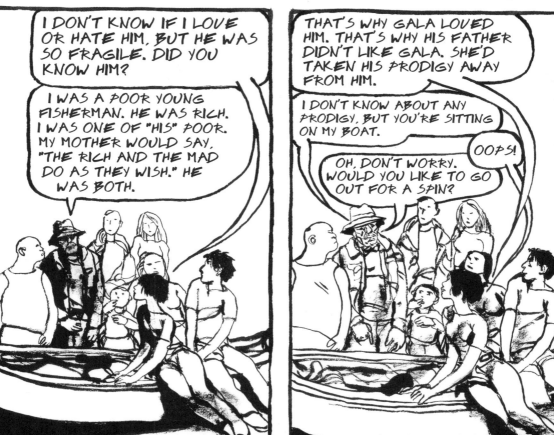

I DON'T KNOW IF I LOVE OR HATE HIM, BUT HE WAS SO FRAGILE. DID YOU KNOW HIM?

I WAS A POOR YOUNG FISHERMAN. HE WAS RICH. I WAS ONE OF "HIS" POOR. MY MOTHER WOULD SAY, "THE RICH AND THE MAD DO AS THEY WISH." HE WAS BOTH.

THAT'S WHY GALA LOVED HIM. THAT'S WHY HIS FATHER DIDN'T LIKE GALA. SHE'D TAKEN HIS PRODIGY AWAY FROM HIM.

I DON'T KNOW ABOUT ANY PRODIGY, BUT YOU'RE SITTING ON MY BOAT.

OOPS!

OH, DON'T WORRY. WOULD YOU LIKE TO GO OUT FOR A SPIN?

A LITTLE HORIZON, A LITTLE SILENCE...
I NEEDED THAT.

I GET A LITTLE MIXED UP WITH ALL THEIR TRIPS BACK AND FORTH TO AMERICA. BUT I KNOW THAT IN LATE 1939 THE DALIS CAME BACK TO FRANCE ON THE SAME BOAT THEY'D FIRST CROSSED ON, THE CHAMPLAIN.

THAT SHIP WOULD SOON RUN INTO A GERMAN MINE AND SINK VERY QUICKLY.

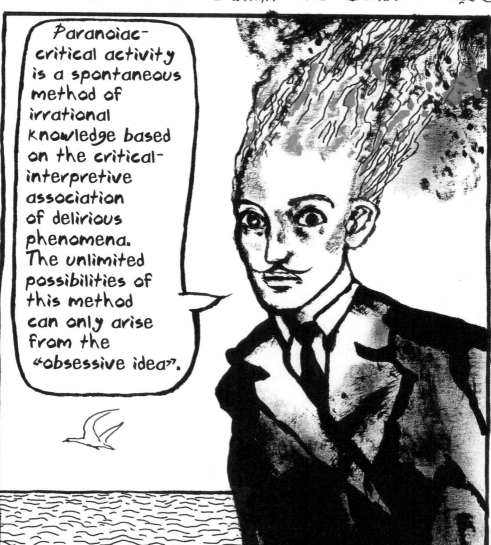

Paranoiac-critical activity is a spontaneous method of irrational knowledge based on the critical-interpretive association of delirious phenomena. The unlimited possibilities of this method can only arise from the "obsessive idea".

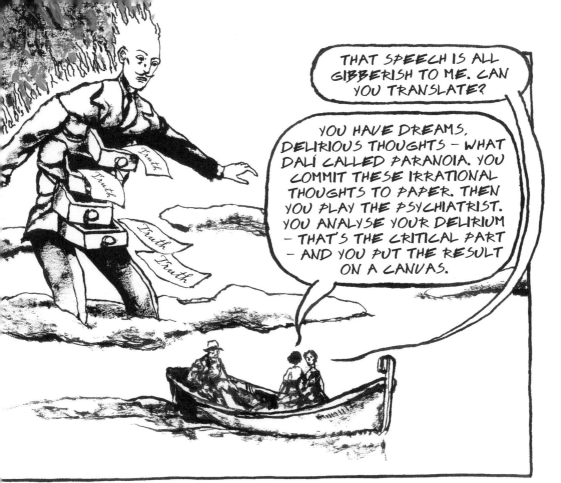

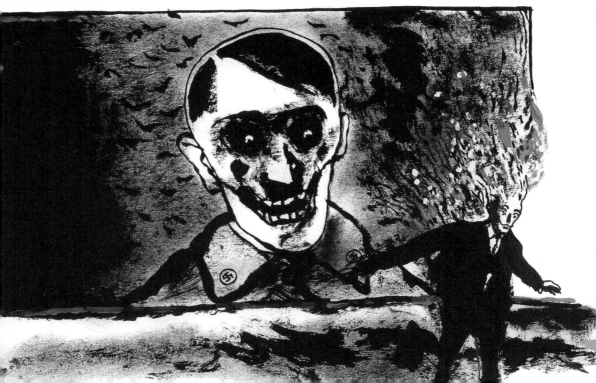

The paranoiac-critical method is purely and simply aimed at supplanting the automatism that is Surrealism's cornerstone.

Moreover, these days your method tends to lapse into entertainments on the order of the crossword puzzle.

And above all, you have been guilty on several occasions of counter-revolutionary acts by glorifying Hitlerian fascism.

Therefore, we the undersigned propose that you be expelled from Surrealism as a fascist element.

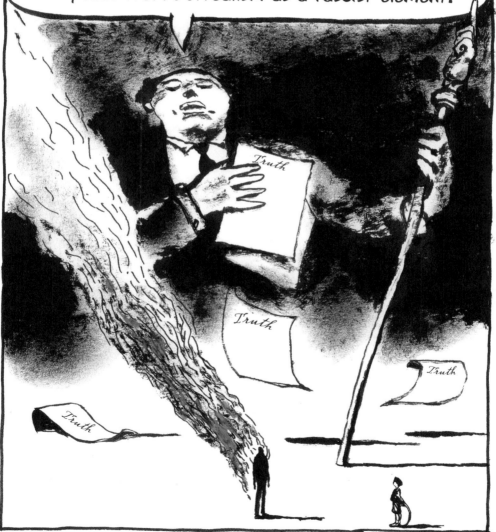

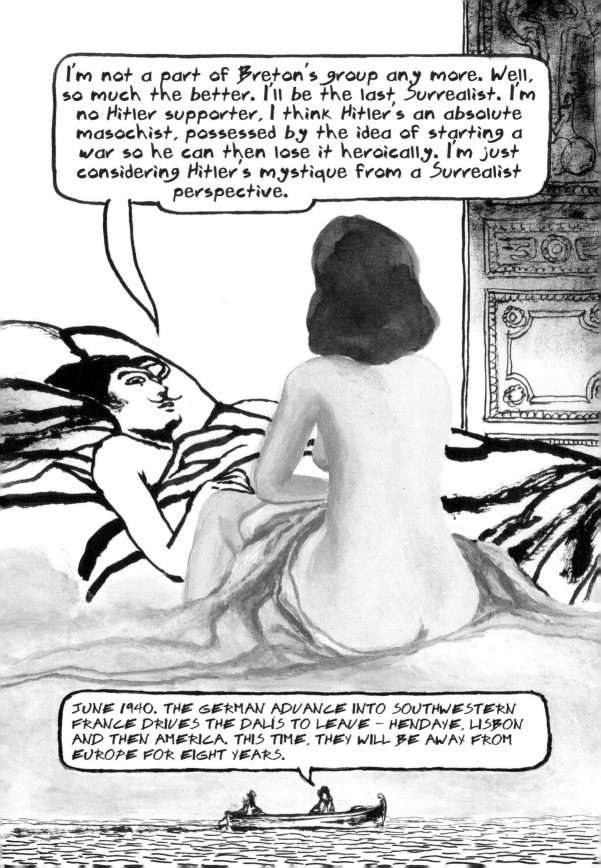

ONCE IN NEW YORK, THEY WILL SETTLE IN VIRGINIA AT THE INVITATION OF CARESSE CROSBY, WRITER AND FOUNDER, WITH HER HUSBAND HARRY, OF AN ENGLISH LANGUAGE PUBLISHING HOUSE IN PARIS, BLACK SUN PRESS. ANAÏS NIN OBSERVES THEM SETTLING IN WITH A SHARP EYE IN HER DIARY.

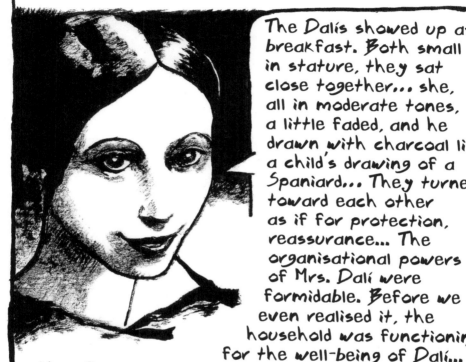

The Dalis showed up at breakfast. Both small in stature, they sat close together... she, all in moderate tones, a little faded, and he drawn with charcoal like a child's drawing of a Spaniard... They turned toward each other as if for protection, reassurance... The organisational powers of Mrs. Dalí were formidable. Before we even realised it, the household was functioning for the well-being of Dalí...

Mrs. Dalí never raised her voice, never seduced or charmed. Quietly she assumed we were all there to serve Dalí, the great, indisputable genius.

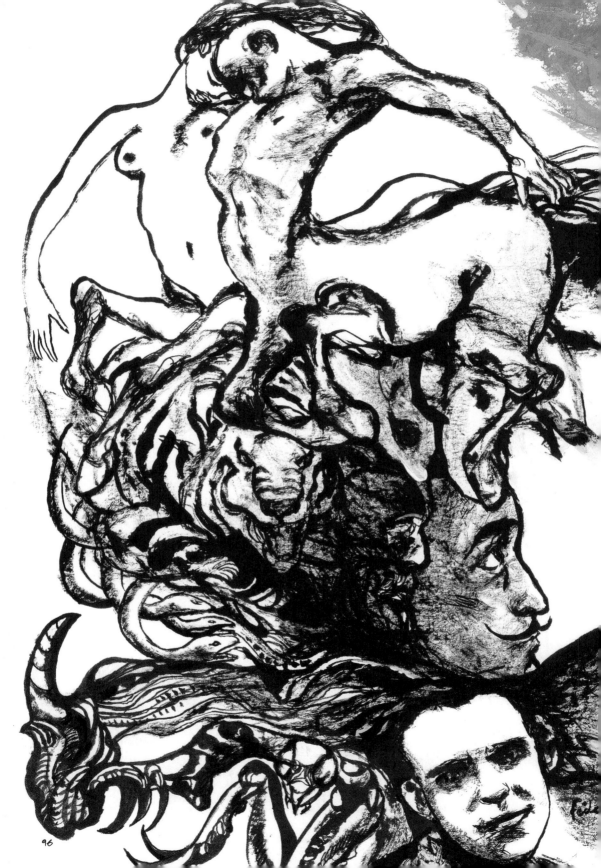

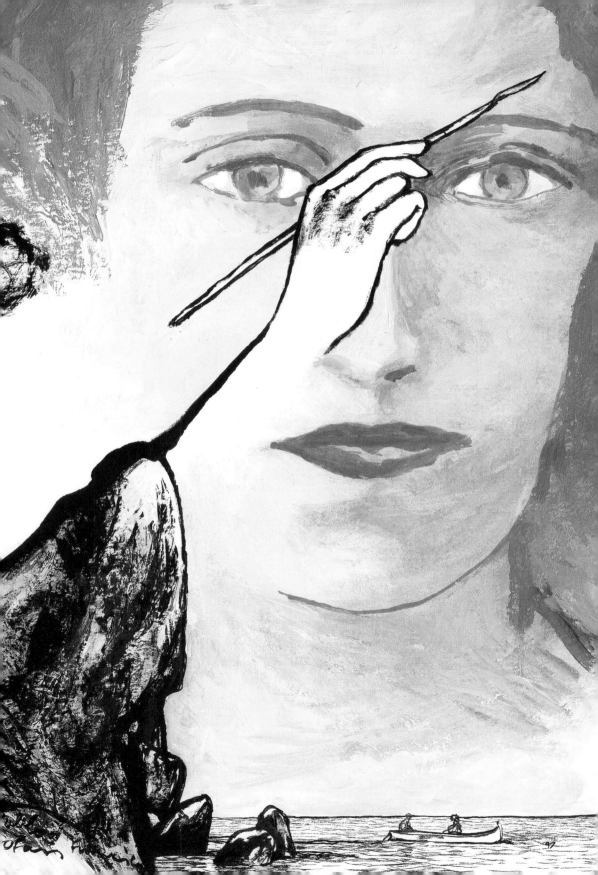

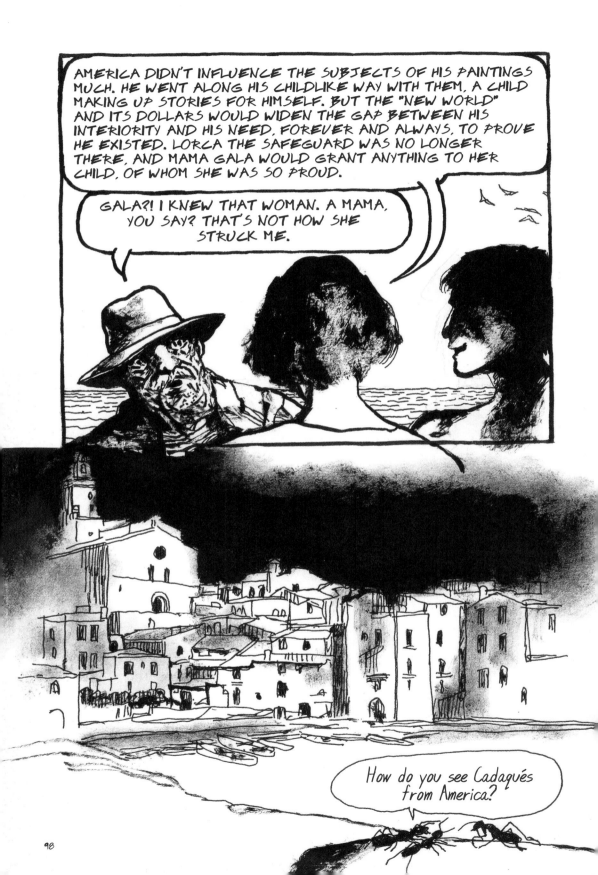

AMERICA DIDN'T INFLUENCE THE SUBJECTS OF HIS PAINTINGS MUCH. HE WENT ALONG HIS CHILDLIKE WAY WITH THEM, A CHILD MAKING UP STORIES FOR HIMSELF. BUT THE "NEW WORLD" AND ITS DOLLARS WOULD WIDEN THE GAP BETWEEN HIS INTERIORITY AND HIS NEED, FOREVER AND ALWAYS, TO PROVE HE EXISTED. LORCA THE SAFEGUARD WAS NO LONGER THERE, AND MAMA GALA WOULD GRANT ANYTHING TO HER CHILD, OF WHOM SHE WAS SO PROUD.

GALA?! I KNEW THAT WOMAN. A MAMA, YOU SAY? THAT'S NOT HOW SHE STRUCK ME.

How do you see Cadaqués from America?

AMERICA IS FAR FROM EUROPE AND THE WAR, BUT
WAR COMES TO IT ANYWAY ON 7 DECEMBER 1941, IN
JAPANESE PLANES. THE COMPANY THE DALÍS KEEP
ACT AS IF IT DOESN'T EXIST (EXCEPT WHEN RAISING
FUNDS FOR BRAVE SOLDIERS).

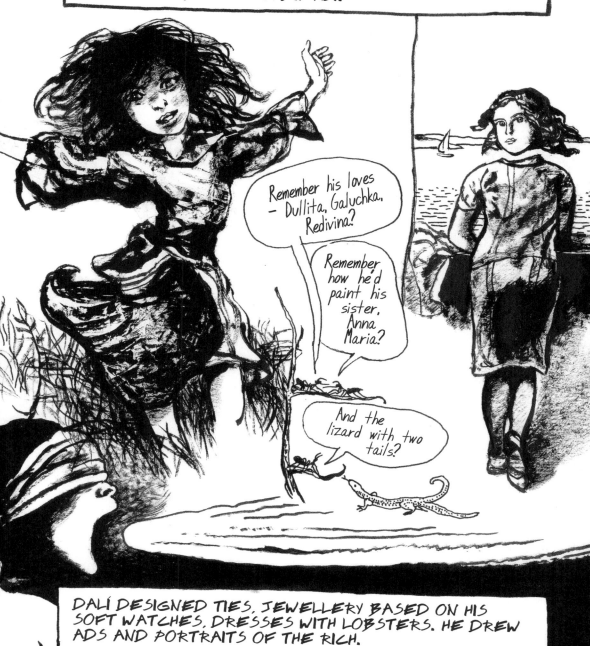

Remember his loves
— Dullita, Galuchka,
Redivina?

Remember
how he'd
paint his
sister,
Anna
Maria?

And the
lizard with two
tails?

DALÍ DESIGNED TIES, JEWELLERY BASED ON HIS
SOFT WATCHES, DRESSES WITH LOBSTERS. HE DREW
ADS AND PORTRAITS OF THE RICH.

THEN, ALL ALONE IN THE STUDIO SET UP FOR HIM AT CARESSE CROSBY'S, HE PAINTED CENTAURS AND AN EGG FROM WHICH A "NEW MAN" HATCHED. WAS THIS DALI?

HE PAINTED "MELANCHOLY", A SOFT SELF-PORTRAIT SUPPORTED BY CRUTCHES, AND "THE FACE OF WAR" WITH THE HEADS OF THE DEAD. HE CREATED THE SETS FOR "LABYRINTH", A RUSSIAN BALLET.

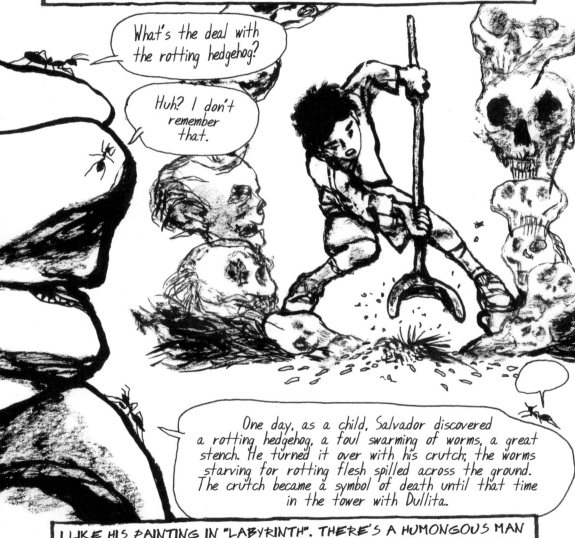

What's the deal with the rotting hedgehog?

Huh? I don't remember that.

One day, as a child, Salvador discovered a rotting hedgehog, a foul swarming of worms, a great stench. He turned it over with his crutch; the worms starving for rotting flesh spilled across the ground. The crutch became a symbol of death until that time in the tower with Dullita.

I LIKE HIS PAINTING IN "LABYRINTH". THERE'S A HUMONGOUS MAN OF STONE. HE HAS AN EGG FOR A HEAD (AGAIN!). A DOORWAY OPENS ON THE DARKNESS OF A TUNNEL DUG INTO HIS CHEST, AND ABOVE THIS OPENING IS THE TATTOO OF AN OLIVE TREE WITH ITS ROOTS.

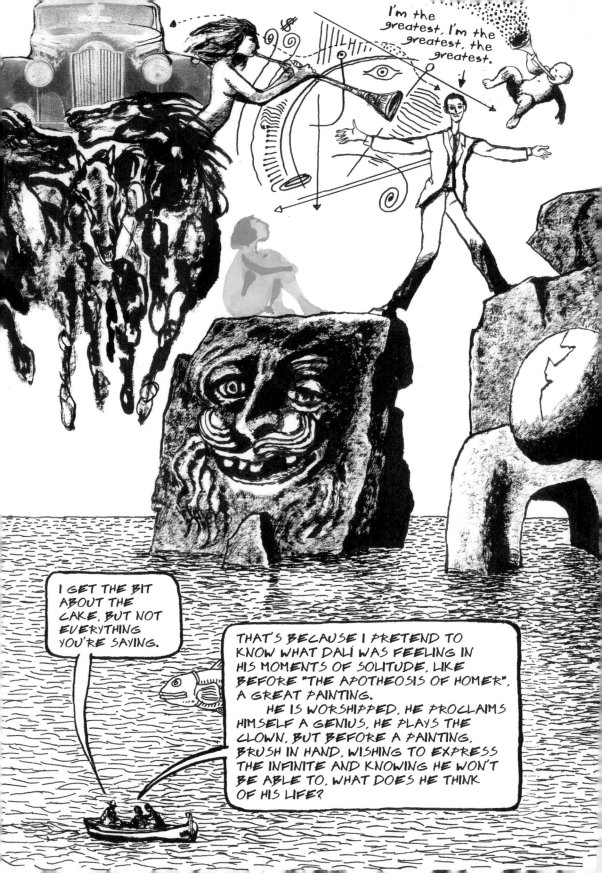

6 AUGUST 1945: HIROSHIMA.

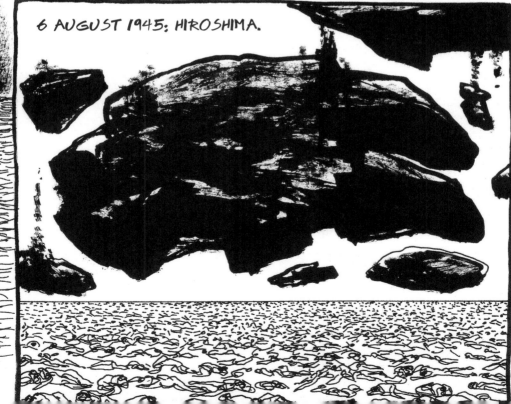

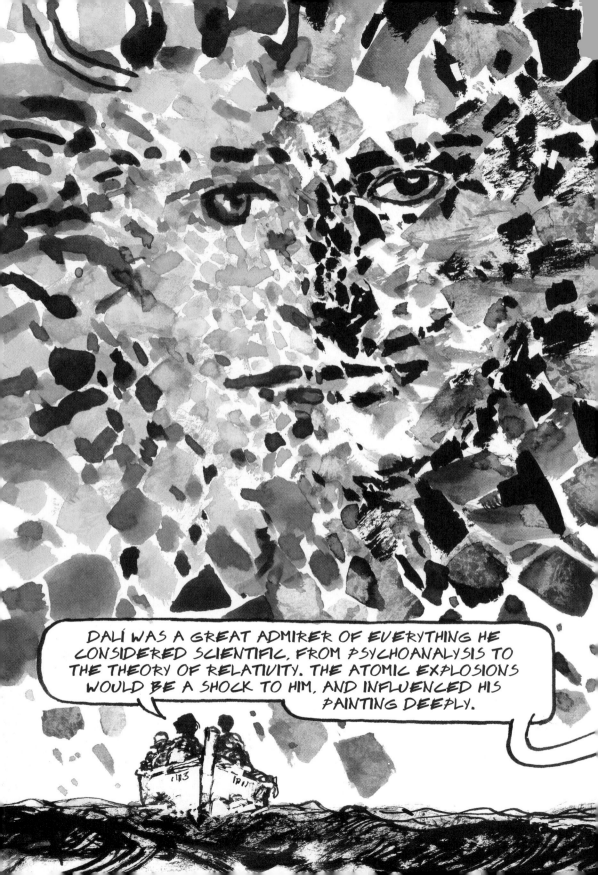

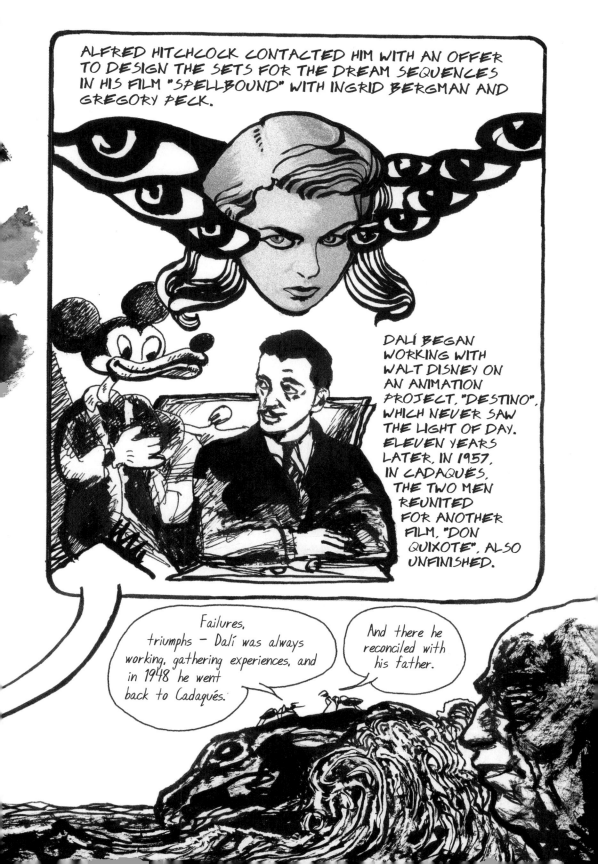

ALFRED HITCHCOCK CONTACTED HIM WITH AN OFFER TO DESIGN THE SETS FOR THE DREAM SEQUENCES IN HIS FILM "SPELLBOUND" WITH INGRID BERGMAN AND GREGORY PECK.

DALÍ BEGAN WORKING WITH WALT DISNEY ON AN ANIMATION PROJECT, "DESTINO", WHICH NEVER SAW THE LIGHT OF DAY. ELEVEN YEARS LATER, IN 1957, IN CADAQUÉS, THE TWO MEN REUNITED FOR ANOTHER FILM, "DON QUIXOTE", ALSO UNFINISHED.

Failures, triumphs — Dalí was always working, gathering experiences, and in 1948 he went back to Cadaqués.

And there he reconciled with his father.

DALÍ PUBLISHED AN ESSAY ENTITLED "MYSTICAL MANIFESTO", IN WHICH HE EXPLAINED THE CHANGE TAKING PLACE WITHIN HIM: "THE TWO MOST SUBVERSIVE THINGS THAT CAN HAPPEN TO AN EX-SURREALIST: FIRST, BECOMING A MYSTIC, AND SECOND, KNOWING HOW TO DRAW. BOTH THESE FORMS OF VIGOUR HAVE JUST HAPPENED TO ME AT THE SAME TIME."

NEXT, HE EXPLAINED THE IMPACT THAT THE EXPLOSION OF THE ATOM BOMB HAD ON HIM, HIS HATRED OF ABSTRACT ART, HIS LOVE FOR ST. THERESA OF AVILA, THE NEED FOR A RETURN TO CLASSICISM IN ART IF ART WAS TO BE SAVED.

AND HE, DALÍ, WISHED TO SAVE ART.

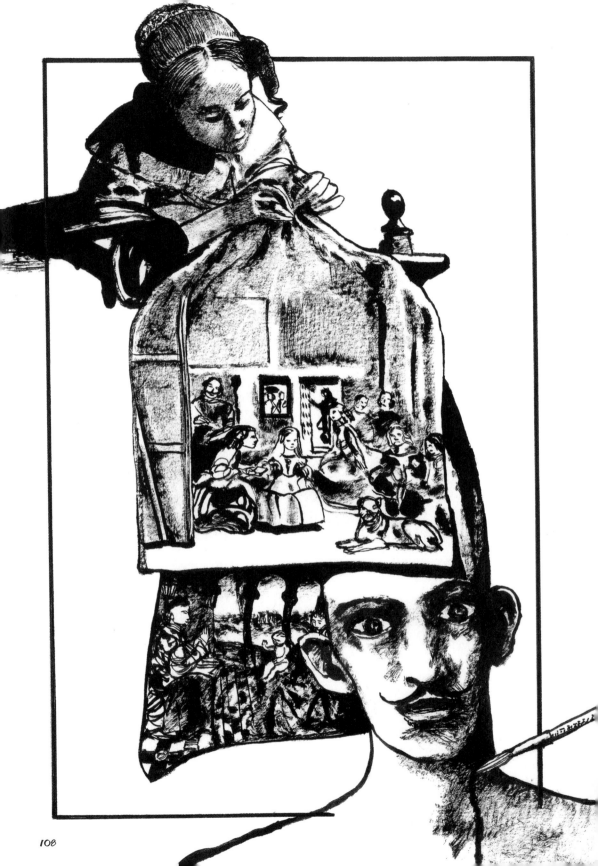

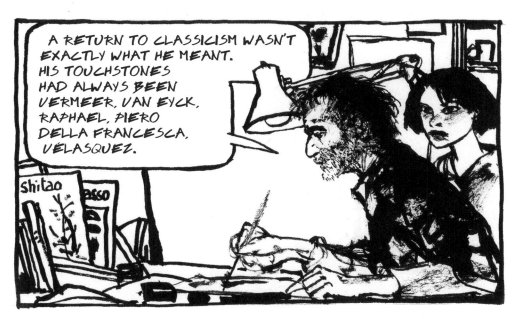

A RETURN TO CLASSICISM WASN'T EXACTLY WHAT HE MEANT. HIS TOUCHSTONES HAD ALWAYS BEEN VERMEER, VAN EYCK, RAPHAEL, PIERO DELLA FRANCESCA, VELASQUEZ.

CLASSICAL IN HIS DELIGHT FOR SEEKING OUT THE SECRETS OF THE ANCIENTS. IN HIS DILIGENCE BEFORE A CANVAS. THAT MANIFESTO WAS ABOVE ALL TO SIGNAL AN END TO THE TRANSGRESSIONS OF HIS YOUTH.

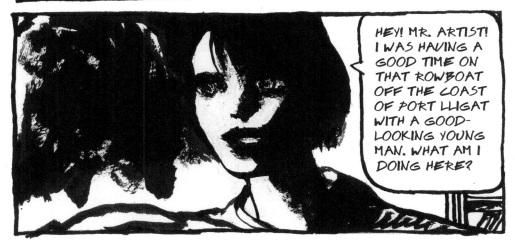

HEY! MR. ARTIST! I WAS HAVING A GOOD TIME ON THAT ROWBOAT OFF THE COAST OF PORT LLIGAT WITH A GOOD-LOOKING YOUNG MAN. WHAT AM I DOING HERE?

YOU'RE HERE NOW BECAUSE I DON'T NEED A ROWBOAT FOR THE REST. OR A HANDSOME YOUNG MAN, AN OLD FISHERMAN, TALKING ANTS OR ROCKS SHAPED LIKE DALÍ'S HEAD. I, TOO, AM RETURNING TO "MY" CLASSICISM, YOU SEE. I NEED YOU HERE FOR CONVERSATION.

BUT YOU NEEDED THEM BEFORE?

WELL, YES. DALÍ IS ENORMOUS. I NEEDED TO KEEP HIM AT A DISTANCE, SO I SET UP A MISE-EN-SCÈNE WITH SEVERAL DOORWAYS. I USED HIS DRAWING STYLE FROM WHEN HE WAS 18, I TRIED TO DRAW LIKE LORCA ON PAGE 45... AND YOU AND THE ANTS WERE SO I WOULDN'T GET STUCK TOO CLOSE TO THAT "MONSTER" – TO SUPPLY A LITTLE OF WHAT I CALL MUSIC.

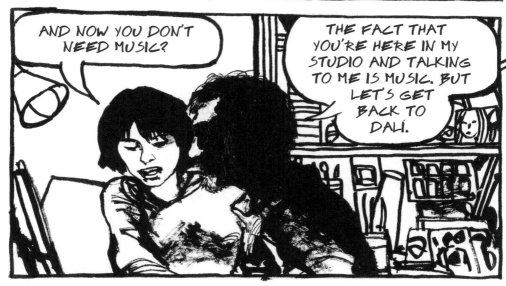

AND NOW YOU DON'T NEED MUSIC?

THE FACT THAT YOU'RE HERE IN MY STUDIO AND TALKING TO ME IS MUSIC. BUT LET'S GET BACK TO DALÍ.

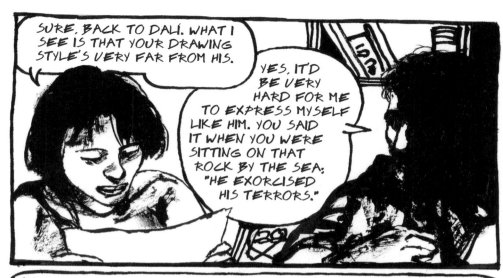

SURE, BACK TO DALÍ. WHAT I SEE IS THAT YOUR DRAWING STYLE'S VERY FAR FROM HIS.

YES, IT'D BE VERY HARD FOR ME TO EXPRESS MYSELF LIKE HIM. YOU SAID IT WHEN YOU WERE SITTING ON THAT ROCK BY THE SEA: "HE EXORCISED HIS TERRORS."

I have no truly felt image of my own body apart from that of a putrefied, rotting corpse, eaten by worms.

HE SORT OF DID WITH HIS PAINTINGS WHAT NATIVE NORTH AMERICANS DID IN GIVING OFFERINGS OF GAME TO THE GREAT SPIRIT, SO HE WOULDN'T COME AND EAT THEM UP.

HE WANTED TO DO ANYTHING HE COULD TO BECOME IMMORTAL.

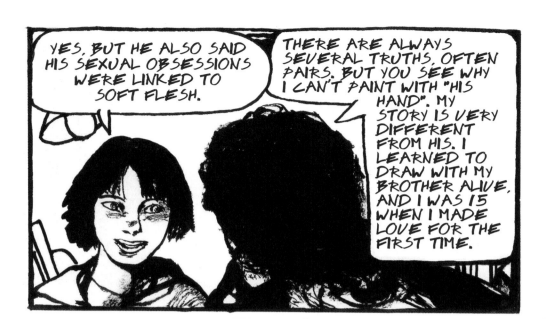

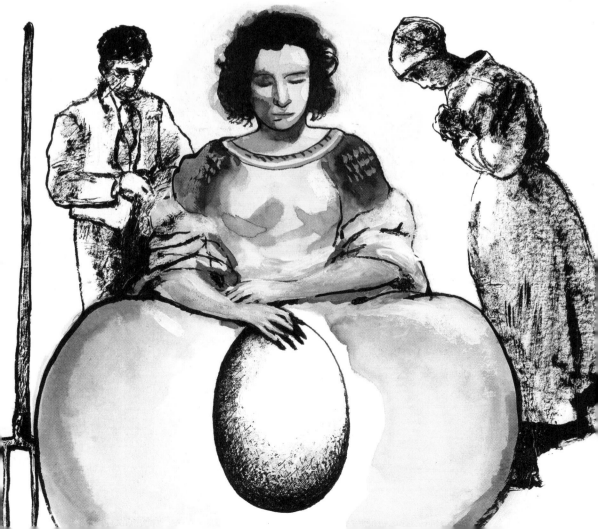

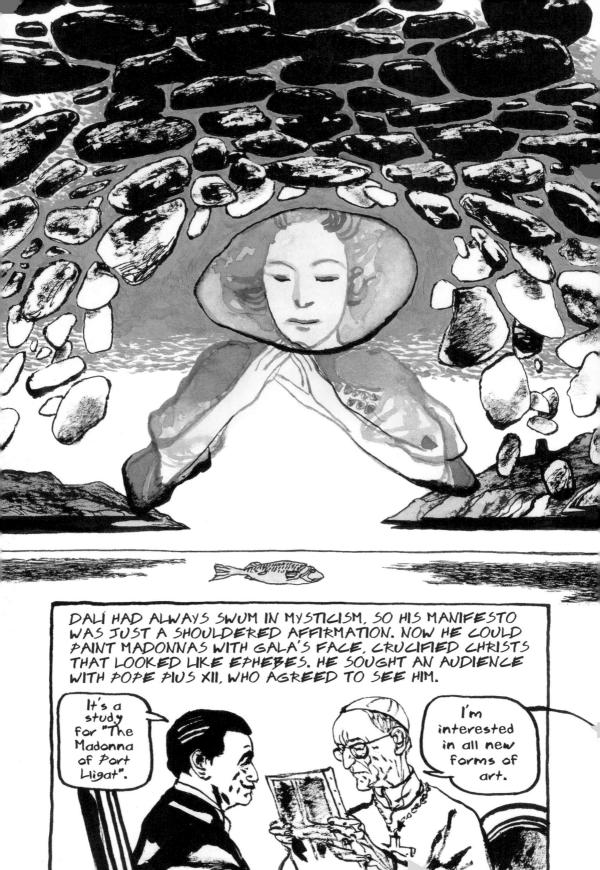

DALÍ HAD ALWAYS SWUM IN MYSTICISM, SO HIS MANIFESTO WAS JUST A SHOULDERED AFFIRMATION. NOW HE COULD PAINT MADONNAS WITH GALA'S FACE, CRUCIFIED CHRISTS THAT LOOKED LIKE EPHEBES. HE SOUGHT AN AUDIENCE WITH POPE PIUS XII, WHO AGREED TO SEE HIM.

It's a study for "The Madonna of Port Lligat".

I'm interested in all new forms of art.

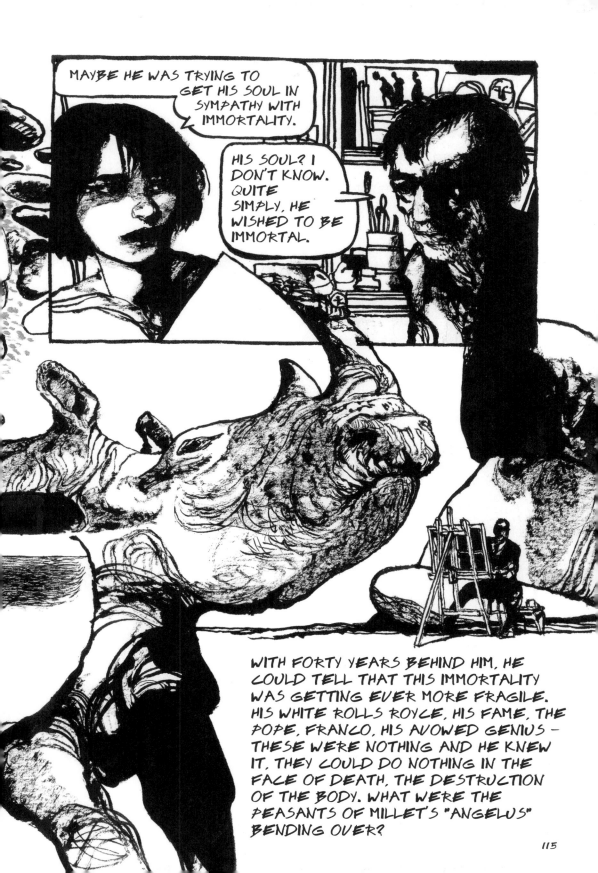

115

SO HE DID MORE AND MORE SHOWS, INVENTED CONCEPTS LIKE THE "PERFECT LOGARITHMIC SPIRAL FOUND IN THE CURVE OF THE RHINOCEROS' HORN". HE SET UP HIS EASEL AT THE ZOO IN VINCENNES AND PAINTED THAT DESCENDANT OF THE MASTODONS, WHICH, HE DECLARED, WAS A PARANOIAC-CRITICAL INTERPRETATION OF VERMEER'S "THE LACEMAKER".

THE RHINOCEROS' HORN: AN ERECT PENIS, HIS MOUSTACHE, ETERNITY.

IN 1950, HIS SISTER ANNA MARIA PUBLISHED "SALVADOR DALI AS SEEN BY HIS SISTER". THE BOOK REOPENED OLD WOUNDS. DALI WOULD NEVER FORGIVE HER.

In 1950, his father died.

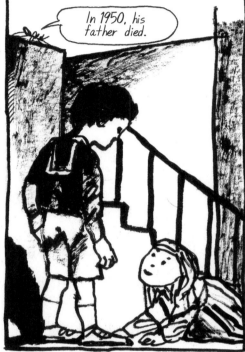

HE DISOWNS ANNA MARIA AND MAKES A PAINTING OF HER, AT HER WINDOW AS BEFORE, BUT NOW WITH BUTT CHEEKS SPREAD: "YOUNG VIRGIN SELF-SODOMISED BY THE HORNS OF HER OWN CHASTITY".

In 1930, I was banished from my family without a cent. My success is my own, with the help of God...

...and the heroic self-sacrifice of a sublime woman, my wife Gala...

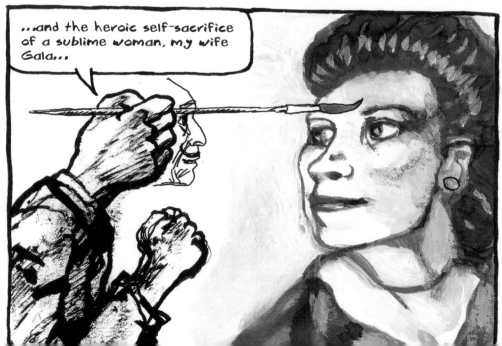

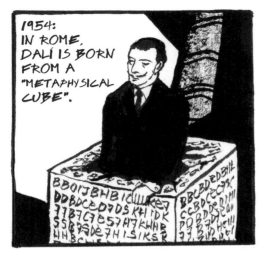

1954:
IN ROME,
DALÍ IS BORN
FROM A
"METAPHYSICAL
CUBE".

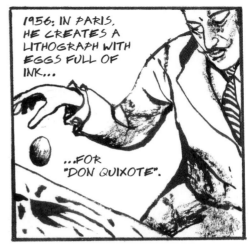

1956: IN PARIS,
HE CREATES A
LITHOGRAPH WITH
EGGS FULL OF
INK...

...FOR
"DON QUIXOTE".

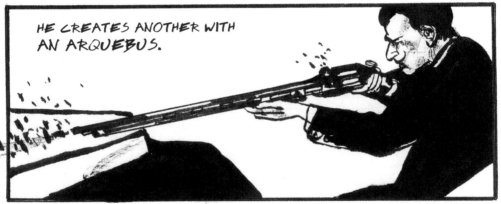

HE CREATES ANOTHER WITH
AN ARQUEBUS.

ANOTHER WITH THE HORNS
OF A RHINOCEROS.

1958:
HE HAS A
12-METRE-LONG
BAGUETTE MADE
BY PARISIAN
BAKERS.

1959:
HE CREATES
ENGRAVINGS FOR
"THE APOCALYPSE
OF ST. JOHN" WITH
A BOMB.

1960: HE PRESENTS HIS
CANVAS "THE DREAM OF
CHRISTOPHER COLUMBUS"
IN NEW YORK.

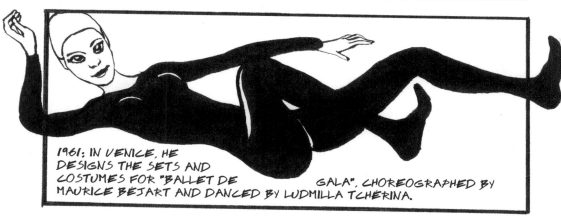

1961: IN VENICE, HE
DESIGNS THE SETS AND
COSTUMES FOR "BALLET DE
MAURICE BEJART AND DANCED BY LUDMILLA TCHERINA.
GALA", CHOREOGRAPHED BY

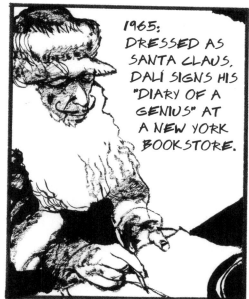

1965:
DRESSED AS
SANTA CLAUS,
DALÍ SIGNS HIS
"DIARY OF A
GENIUS" AT
A NEW YORK
BOOKSTORE.

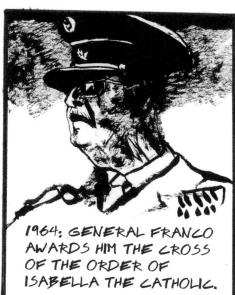

1964: GENERAL FRANCO
AWARDS HIM THE CROSS
OF THE ORDER OF
ISABELLA THE CATHOLIC.

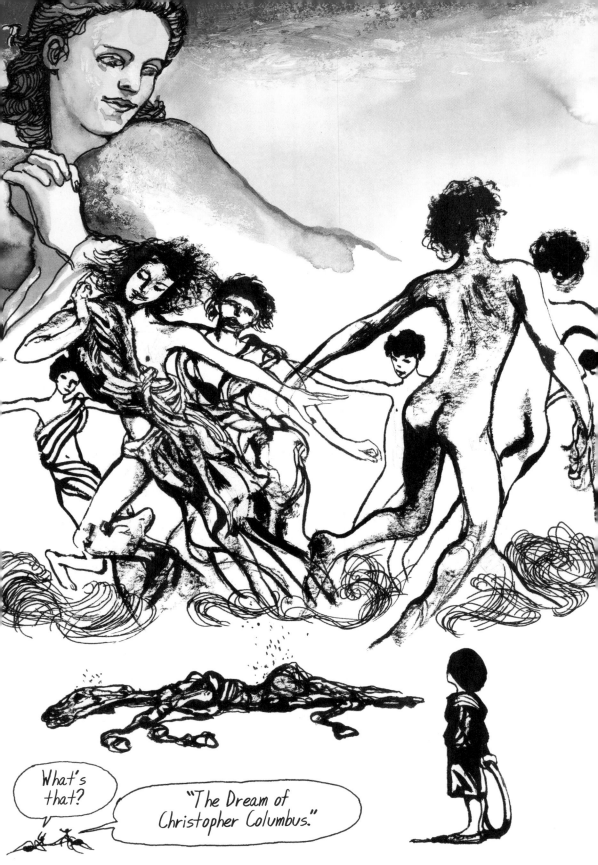

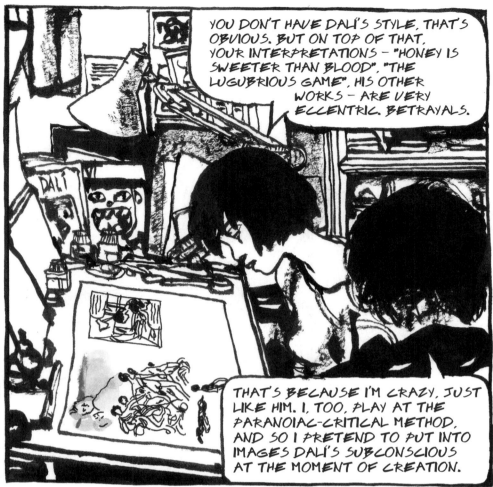

YOU DON'T HAVE DALI'S STYLE, THAT'S OBVIOUS. BUT ON TOP OF THAT, YOUR INTERPRETATIONS – "HONEY IS SWEETER THAN BLOOD", "THE LUGUBRIOUS GAME", HIS OTHER WORKS – ARE VERY ECCENTRIC. BETRAYALS.

THAT'S BECAUSE I'M CRAZY, JUST LIKE HIM. I, TOO, PLAY AT THE PARANOIAC-CRITICAL METHOD, AND SO I PRETEND TO PUT INTO IMAGES DALI'S SUBCONSCIOUS AT THE MOMENT OF CREATION.

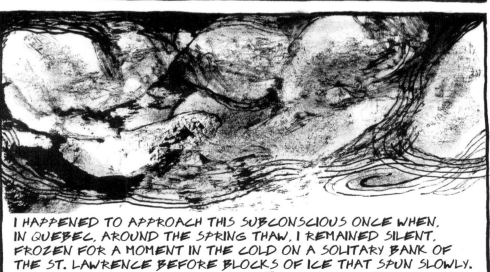

I HAPPENED TO APPROACH THIS SUBCONSCIOUS ONCE WHEN, IN QUEBEC, AROUND THE SPRING THAW, I REMAINED SILENT, FROZEN FOR A MOMENT IN THE COLD ON A SOLITARY BANK OF THE ST. LAWRENCE BEFORE BLOCKS OF ICE THAT SPUN SLOWLY.

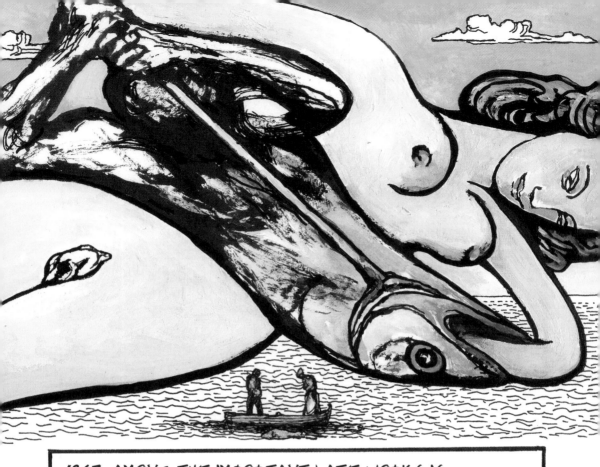

1967: AMONG THE IMPORTANT LATE WORKS IS "TUNA FISHING". IT TOOK DALÍ TWO SUMMERS TO PAINT AND IS A SORT OF TESTAMENT, THE RESULT OF FORTY YEARS OF PASSIONATE EXPERIMENTS, CONTAINING ALL HIS TRENDS: SURREALISM, ART POMPIER, ACTION PAINTING, POINTILLISM, ABSTRACTION, TACHISM, PSYCHEDELIC POP ART.

DALÍ HAD ALWAYS USED PHOTOGRAPHY AND, EVER ENAMORED OF SCIENCE, TOOK ADVANTAGE OF ALL THE INVENTIONS THAT COULD HELP HIM CREATE HIS WORK: HOLOGRAPHY, LASERS, STEREOSCOPY. DALÍ WISHED TO UNITE ART AND MODERN TECHNOLOGY.

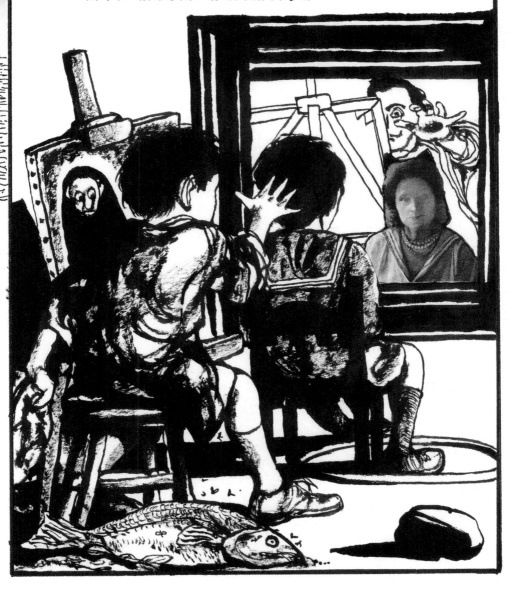

1968: DALÍ HAS COTTON CANDY WITH AMANDA LEAR. HE GETS A WAX STATUE OF HIMSELF AT THE MUSÉE GRÉVIN.

1969: HE PUBLISHES "MÉTAMORPHOSES ÉROTIQUES".

1970: EXHIBITION IN NEW YORK AND CREATION OF POSTERS FOR THE FRENCH RAILWAYS.

1971: COVER OF "VOGUE" WITH A DOUBLE PORTRAIT OF MAO-MARILYN.

1972–1973: HE PAINTS "DALÍ FROM THE BACK PAINTING GALA FROM THE BACK ETERNALISED BY SIX VIRTUAL CORNEAS PROVISIONALLY REFLECTED BY SIX REAL MIRRORS" (UNFINISHED).

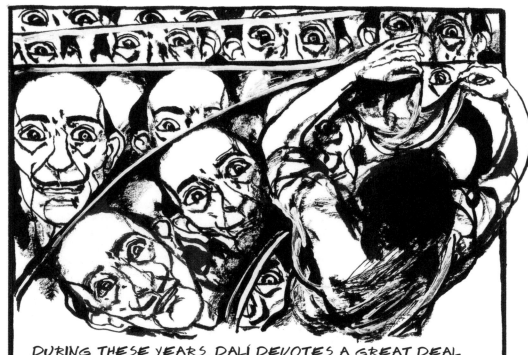

DURING THESE YEARS, DALÍ DEVOTES A GREAT DEAL
OF HIS TIME TO PERFECTING HIS IMAGE, MAKING MASKS
FOR HIMSELF. BUT A MASK IS LIKE THE SURFACE OF THE
SEA: IT DOESN'T SAY WHAT LIES BENEATH. AND YET A
FISHERMAN WILL PICK A SPOT BASED ON THE SIGHT OF
THIS SURFACE.

1978: AT THE SOLOMON R. GUGGENHEIM MUSEUM IN NEW
YORK, DALÍ PRESENTS HIS HYPERSTEREOSCOPIC PAINTING
"DALÍ LIFTING THE SKIN OF THE MEDITERRANEAN TO SHOW
GALA THE BIRTH OF VENUS".

HE IS 74 YEARS OLD. HE MEETS ANDY WARHOL, WHO IS 50.

You intimidate me. You're a master at managing an artistic career.

A genius.

But you mustn't be intimidated, your style's very good as well.

Why is he wearing a wig?

But I don't have your "grandeur". That bit with the diving helmet was wonderful.

Why... you do know I almost died, don't you?

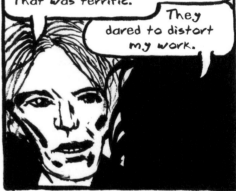

And the display window you demolished on Fifth Avenue! That was terrific.

They dared to distort my work.

You are young, Warhol, and of your time. I made my genius yield a profit, but you swim freely in the market.

Getting the public's attention is like eating peanuts: once you start, you can't stop.

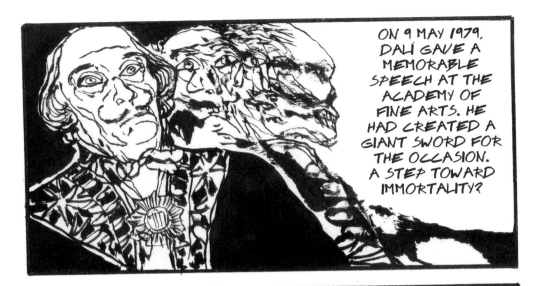

ON 9 MAY 1979, DALÍ GAVE A MEMORABLE SPEECH AT THE ACADEMY OF FINE ARTS. HE HAD CREATED A GIANT SWORD FOR THE OCCASION. A STEP TOWARD IMMORTALITY?

THAT SAME YEAR, THE POMPIDOU CENTRE ORGANISED A MAJOR RETROSPECTIVE OF HIS WORK, FIRST IN PARIS AND THEN AT THE TATE GALLERY IN LONDON.

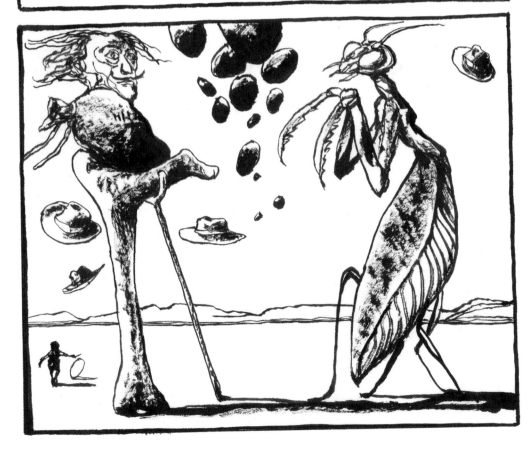

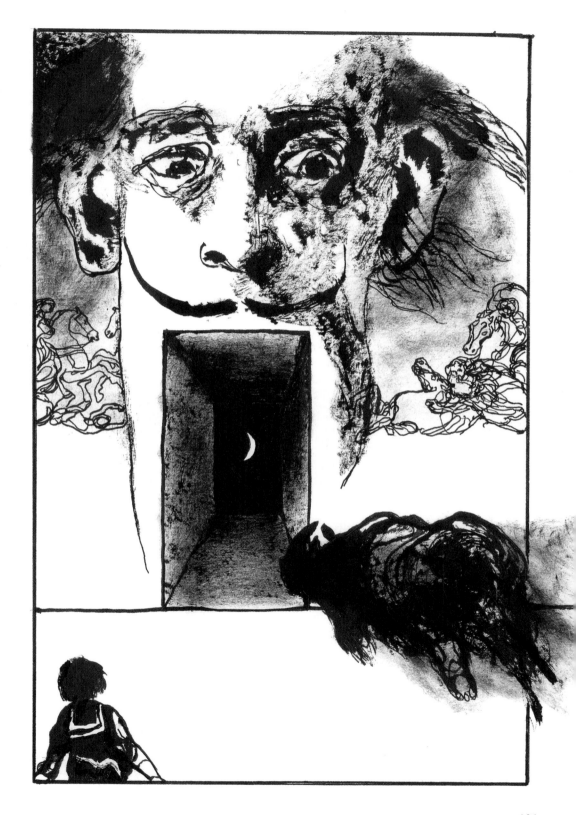

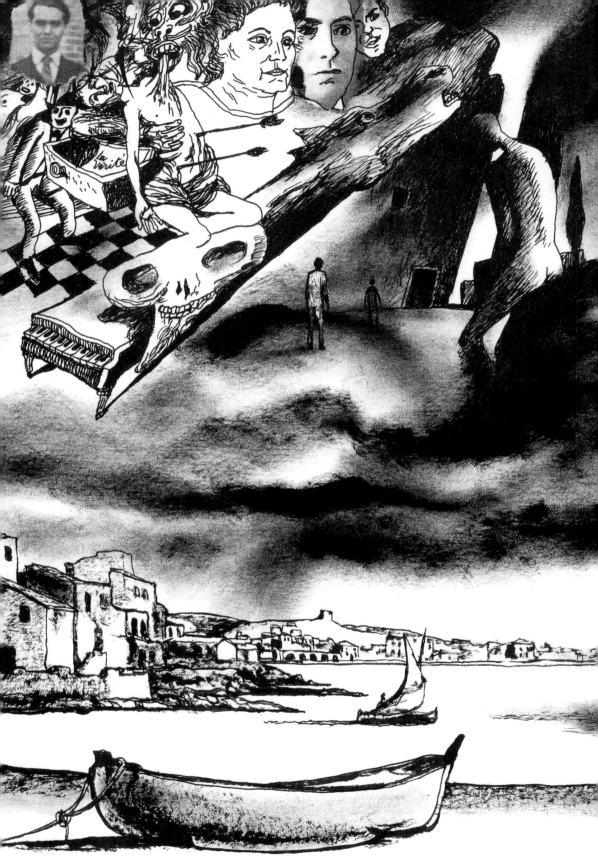

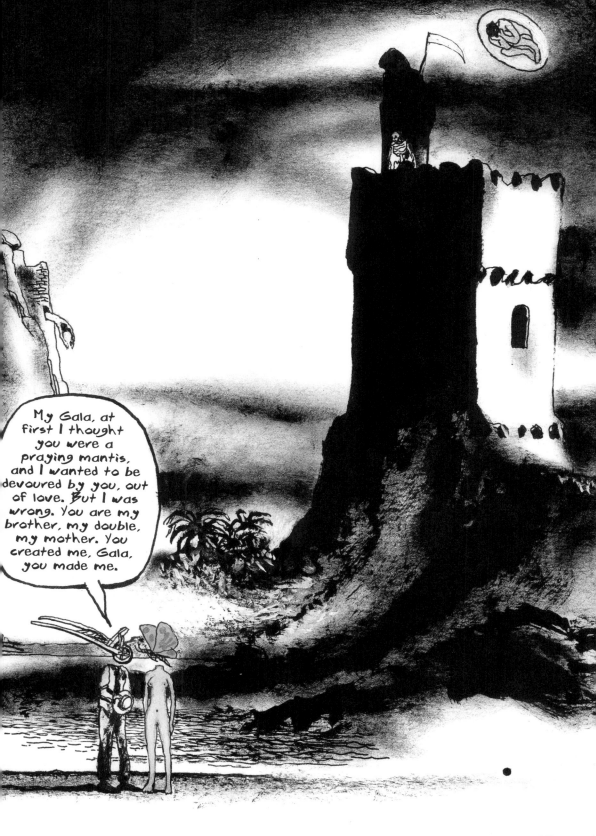

129

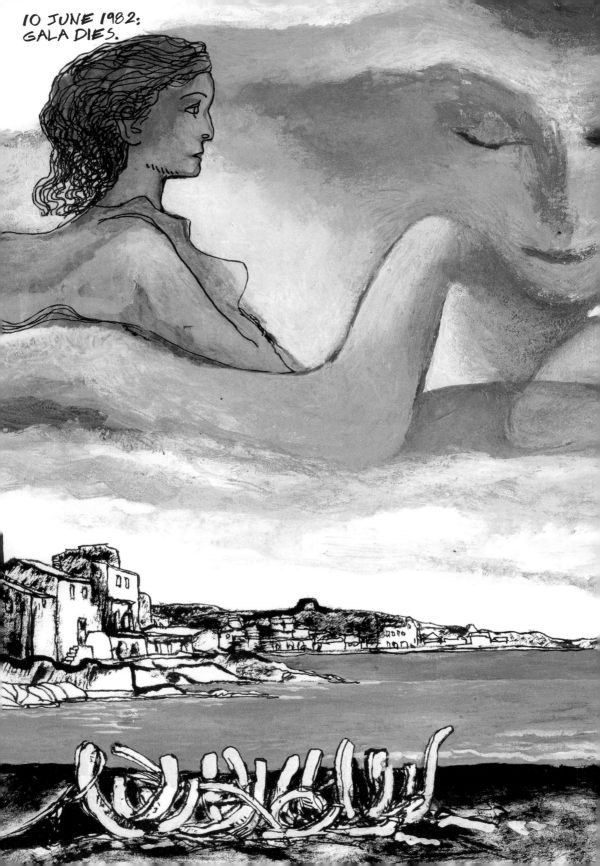

10 JUNE 1982:
GALA DIES.

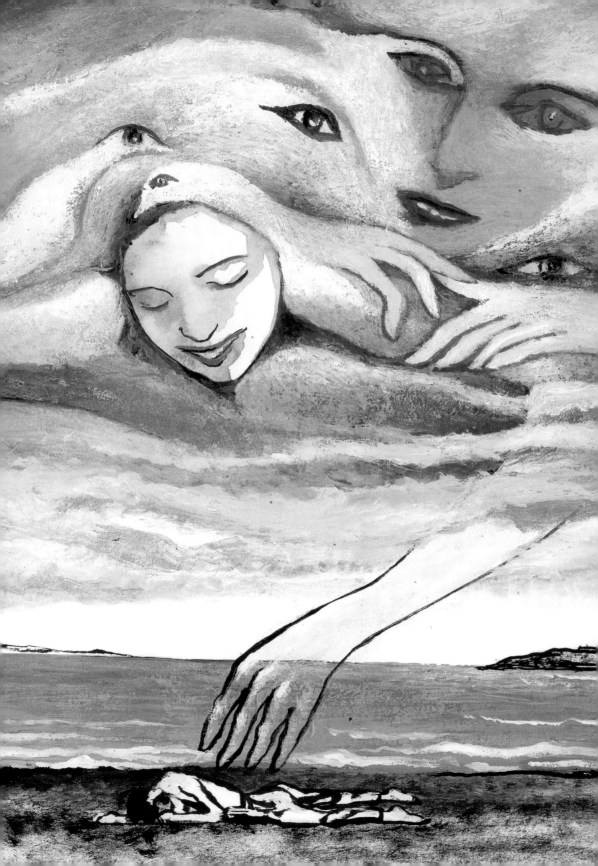

AND THEN... AND THEN, THERE WAS NO
MORE "AND THEN". THERE WERE DAYS,
NIGHTS, DAYS. SALVADOR DALÍ HAD
STOPPED BELIEVING IN IMMORTALITY,
IN ETERNITY, IN THE DESIRE TO WALK
AMONG THE STARS – THERE WAS TOO
MUCH OF SALVADOR DALÍ BENEATH
THE EARTH. HE STILL DONNED A FEW
DISGUISES, OUT OF SCORN FOR SCORN.
IN 1983, HE PAINTED HIS FINAL PAINTING,
"THE SWALLOW'S TAIL". HE WAS
BADLY BURNED DURING A FIRE IN HIS
BEDROOM AT THE CASTELL DE PÚBOL
IN 1984. AND THEN CAME MORE NIGHTS,
MORE DAYS, MORE NIGHTS.

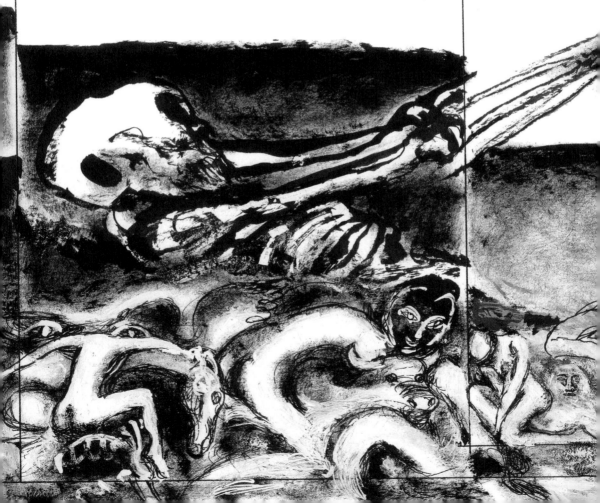

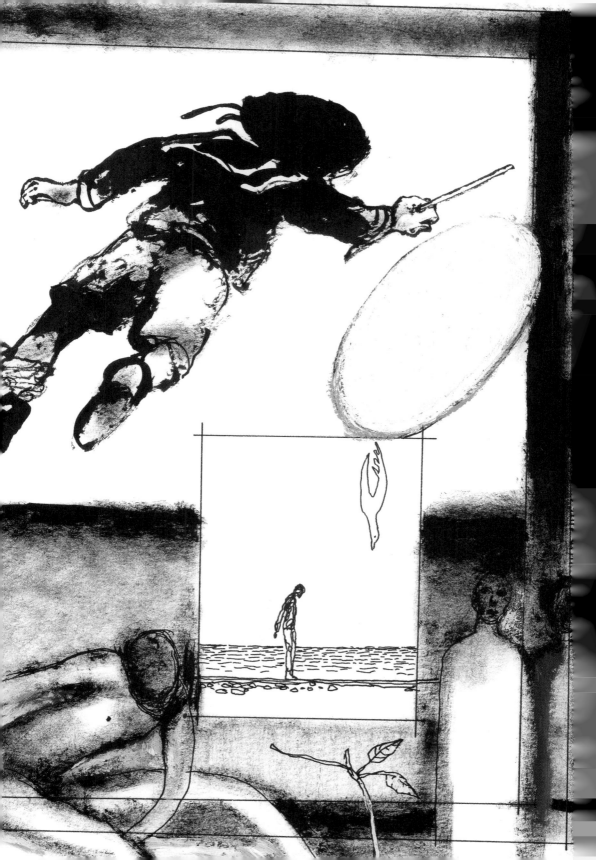

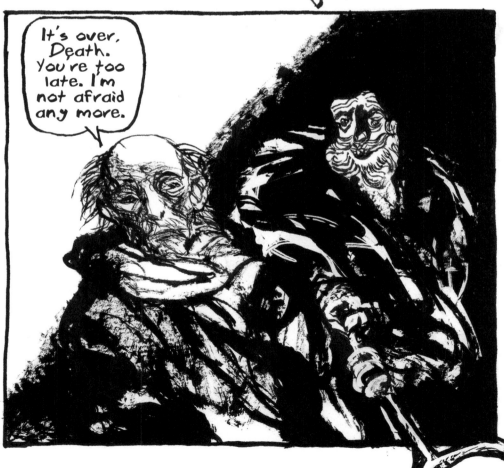

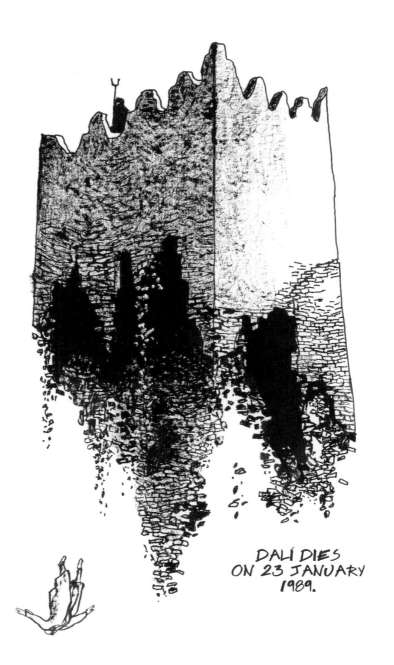

DALÍ DIES
ON 23 JANUARY
1989.

BAUDOIN
2012

SALVADOR DALÍ
1904–1989

After each section, we have noted some of Salvador Dalí's major works produced in that period. For a complete catalogue of his paintings, see Robert Descharnes and Gilles Néret's Dalí: The Paintings, 1904–1946 (Book I) *and* Dalí: The Paintings, 1946–1989 (Book II), Paris, Taschen, 1994.

Salvador Domingo Felipe Jacinto Dalí was born on 11 May 1904 in Figueres, Spain, the second son of Salvador Dalí i Cusí, a lawyer, and Felipa Domènech Ferrés. His older brother, also named Salvador, had been born on 12 October 1901 and died 1 August 1903. In 1908, his only sister, Anna Maria, was born. In 1910, his father decided to enroll him in the Hispano–French School of the Immaculate Conception in Figueres, where he learned French, the language that was to become his cultural vehicle, though he did not shine in his studies. His first painting probably dates from this period: *Landscape Near Figueras (1910–1914)*. In the summer of 1916, at El Molino de la Torre (The Tower Mill), an estate owned by the Pichots – a family of intellectuals and artists, friends of Dalí's parents – the young boy discovered Impressionism through the collection of artist Ramón Pichot, a close friend of Pablo Picasso's who had spent the summer of 1910 in Cadaqués. After a mediocre performance in primary school, Dalí began his secondary schooling in the autumn at the Marist Brothers' school and the high school in Figueres. He also attended classes at the Municipal Drawing School in Figueres under Juan Núñez, an art professor who was influential in the area. Dalí often made drawings for his sister when she was ill.

Old Man at Twilight

1919–1921
Taking part in a group exhibition in the salons of the Societat de Concerts at Figueres' Municipal Theatre (later to become the Dalí Theatre-Museum), Dalí sold his first works. The press predicted a bright future for him as a painter. With a group of high school friends, he founded the magazine *Studium*, in which he published his first writings: a regular art column devoted to artists he admired (Goya, El Gréco, Dürer, Leonardo da Vinci, Michelangelo and Vélasquez). During this time, Dalí claimed to be an Impressionist and praised Monet, Degas and Manet. Faced with his son's desire to pursue an artistic calling, Dalí's father made him promise to enroll at the Royal Academy of Fine Arts in Madrid so he could be trained as a teacher. Dalí spent summers with his family, painting in Cadaqués, his father's birthplace, near the Pichots. There he found an appropriate refuge for his painterly activities. In February 1921, his mother died.

Self-Portrait with Raphaelesque Neck

1922

Dalí finished his secondary schooling with honours. In Madrid, he graduated to the Royal Academy of Fine Arts of San Fernando and lived at the Residencia de Estudiantes, where he befriended a group of young people who were to become leading intellectual and artistic figures: Luis Buñuel, Federico García Lorca, Pedro Garfias, Eugenio Montes and Pepín Bello, among others. He worked assiduously and spent his free time at the Prado, but his comrades' disillusion soon caught up to him. At the time, he witnessed the birth of Cubism via the Futurist catalogue *Futurist Painting and Sculpture (Plastic Dynamism)*, which Pepito Pichot had brought back from Paris, as well as foreign art revues *(Esprit Nouveau* and *Valori Plastici)*. His maternal grandmother died, and his father married Catalina Domènech Ferrés, his mother Felipa's sister.

1923

The disciplinary council of the Academy of San Fernando suspended him for a year: he was charged with leading a student protest over the fact that painter Daniel Vázquez Díaz had not been made Chair of Painting. Dalí returned to Figueres, taking up his classes again with Juan Núñez, who taught him etching.

Nude in a Landscape
The Sick Child (Self-Portrait)
Cubist Self-Portrait

1924

Dalí's drawings were published in the revues *Alfar* and *España*. In May, he was briefly imprisoned, almost certainly in retaliation against his father, who had a Marxist and anti-monarchist past and claimed the most recent elections had been rigged. Dalí would speak of this episode for the rest of his days, recalling that his stay in jail had been a pleasant time where he was the centre of attention, with everyone admiring his humour and bravery. In the autumn, he returned to the Academy and came out of his shell a bit, acting in one of Buñuel's plays. He provided illustrations for his friend Carles Fages de Climent's book *The Witches of Llers*. Dalí spent happy, carefree days with his group of friends, even though he admitted to being occasionally jealous of García Lorca and his charisma.

Portrait of My Sister
Portrait of Luis Buñuel
Portrait of a Girl in a Landscape
 (Cadaqués)

1925

Dalí spent Easter vacation in Cadaqués with García Lorca. They began a long correspondence – the painter's letters survive, but rarely the poet's – that bears witness to the richness of the relationship between two men who mutually influenced each other's work. Dalí took part in the First Exhibition of the Iberian Artists' Society in Madrid. That same year, he had his first solo show at the Galeries Dalmau in Barcelona. Some of the works displayed in these shows were situated halfway between the Cubist trends then in fashion and the works of the Italian metaphysical painters he had studied in *Valori Plastici*. During this time, he rejected the vanguard, seeking an essentially Italian pictorial tradition. He did not return to the Academy of San Fernando for the 1925–26 academic year.

Figure at a Window (Anna Maria)
Back of Girl (Noia d'Esquena)
Portrait of my Father

1926

He took part in several exhibitions, among them one dedicated to modern Catalan art (the First Autumn Salon in Barcelona's Sala Parés) and the Exhibition of New Catalan Pictorial Art,

which brought a selection of works by foreign avant-garde artists to the Galeries Dalmau. In the company of his aunt and sister, he went to Paris for the first time. There he met Picasso, and with Buñuel visited the Louvre, Millet's studio in Fontainebleau and Versailles. They made the rounds of galleries, meeting everyone. On 20 June, he was permanently expelled from the Royal Academy of Fine Arts in Madrid for declaring the board of examiners that was to review him incompetent. He returned to Figueres once more and devoted himself intensely to painting.

Girl from Behind (Anna Maria)
Woman at a Window in Figueres
The Basket of Bread
Neo-Cubist Academy
 (Composition with Three Figures)

1927

Dalí did his compulsory military service at Sant Ferran Castle in Figueres. He designed the set for Adrià Gual's *The Harlequin Family* and the costumes for García Lorca's *Mariana Pineda* at the Teatre Goya in Barcelona. With publication of the article "San Sebastián", devoted to Lorca, Dalí became a regular and extensive contributor to the avant-garde revue *L'Amic de les Arts*, a relationship that was to continue for the next two years. In September, Miró and his dealer Pierre Loeb visited the artist in Figueres. Loeb found Dalí still too influenced by others, and said he wanted to wait and see Dalí's own character emerge.

After his show at the Galeries Dalmau in Barcelona, however, Paul Rosenberg sought to contact Dalí on several occasions. In October, Dalí took part in the Second Autumn Salon at the Sala Parés. His works here revealed the first clear influences of Surrealism, as well as what would become recurring elements: amputated bodies, severed parts (hands, heads, bodies) and decomposing animals.

Barcelonese Mannequin
Honey Is Sweeter Than Blood

1928

Dalí took part in the collective exhibition "Manifestation d'Art d'Avant-garde" for the first anniversary of *La Gaceta Literaria*, which published his poem "To Lidia of Cadaqués" and his article "Reality and Surreality". Along with Lluís Montanyà and Sebastià Gasch, he published the *Yellow Manifesto* (also known as the *Catalan Anti-Artistic Manifesto* or *Manifesto Groc*), which amounted to a fierce attack on conventional art. They themselves were accused of being "futurists" – in other words, passé. Relations between Dalí and Lorca suffered a brief cool spell when Dalí proved critical of the poet's latest collection, *Gypsy Ballads* – but this did not affect their deep friendship. In October, Dalí took part in the Third Autumn Salon at the Sala Parés and saw his work *Two Figures on a Beach: Unsatisfied Desires* rejected for obscenity. He then showed at the Twenty-seventh International Exhibition of Paintings in Pittsburgh, United States. A few days later, the Galeries Dalmau decided to show the banned painting – concealing, however, the part evocative of a vulva in order to avoid controversy.

Sterile Efforts. Cenicitas (Little Ashes)
Two Figures on a Beach: Unsatisfied
 Desires
Inaugural Gooseflesh
The Donkey's Carcass

1929

This was a pivotal year for Dalí, full of highly emotional events. In January, he collaborated with Luis Buñuel on the script for *Un Chien Andalou*, initially entitled "It's Dangerous to Lean and Look Inside". He took part in the Exhibition of Paintings and Sculptures

by Spanish Artists Living in Paris, held at the Botanical Garden in Madrid. The public paid particular attention to the works he showed. The final issue of *L'Amic de les Arts* was published; Dalí had written most of the articles, which amounted to a profession of faith in Surrealism. He travelled again to Paris in mid-April and stayed until June to help shoot *Un Chien Andalou*, spending time with his friend Joan Miró, who introduced him to the Surrealists headed by André Breton. He also met René Magritte, artist Jean Arp and gallery owner Camille Goemans, who introduced him to Paul Éluard. Dalí signed a contract to show at the Galerie Goemans in Paris in the autumn. Under the title "Paris-Documentary 1929", Barcelona newspaper *La Publicitat* published the seven articles that gathered Dalí's impressions of what he had witnessed in the City of Lights. *Un Chien Andalou* premiered at the Studio des Ursulines in Paris, and was screened for the public at Studio 28. The free-spirited and disturbing film did not lack for reactions. Dalí decided to spend the summer in Cadaqués, a home base for him, where he received visits from Camille Goemans and his ladyfriend, Magritte and his wife, Buñuel, Paul Éluard and his wife Gala, and their daughter Cécile. Gala, who had fallen in love with Dalí, was never to leave his side from then on. On 25 November, Dalí's first individual exhibition in Paris opened at the Galerie Goemans, with the catalogue prefaced by André Breton. Relations between the painter and his family deteriorated considerably as his love for Gala grew. His father disowned him, probably due to his affair with a married woman and the painting *Sometimes I Spit on the Portrait of My Mother for the Fun of It*, on display at the Galerie Goemans. Buñuel was a witness to this rift, during a trip to Figueres to work with Dalí on their new project, *The Golden Age*.

Sometimes I Spit on the Portrait of
 My Mother for the Fun of It
The Lugubrious Game
The Enigma of Desire: My Mother,
 My Mother, My Mother
The Great Masturbator

1930

Dalí began painting *The Invisible Man*, which he would finish in 1933. At the same time, he wrote *La Femme Visible* (*The Visible Woman*), a collection of four texts including "The Donkey's Carcass", published in December by Les Éditions Surréalistes. Upon learning that the Galerie Goemans was about to go under, the Viscount of Noailles offered to become Dalí's patron. In order to build himself a house in Cadaqués, the artist accepted. From Lídia Noguer, he bought a small fisherman's house in Port Lligat, and spent every year from spring to autumn there, adding rooms whenever he could. This choice greatly upset his father, who did everything he could to drive Dalí out. Dalí took part in the final show at the Galerie Goemans along with Arp, Braque, Duchamp, Ernst, Gris, Miró, Magritte, Man Ray, Picabia, Picasso and Tanguy. Dalí was firmly part of the Surrealists; Breton saw in him the group's sorely needed renewal. The Viscount of Noailles introduced him to Pierre Colle and Alfred H. Barr, who urged him to come to New York. *The Golden Age* was screened at Studio 28, but the authorities soon banned further showings because the film had stirred riots. *La Femme Visible* appeared with a preface by Breton and Éluard. Upon reading it, Dalí's father was so disgusted that he disinherited his son once and for all.

The Hand – The Remorse of Conscience
Invisible Sleeping Woman, Horse, Lion
The Persistence of Memory

1931

The Second Republic was declared in Spain. The Surrealists protested and denounced the bourgeois aspects of this new regime in a pamphlet entitled *Au Feu! (Fire!)*. Notable signees included Dalí and Buñuel. The artist's first individual exhibition was held at the Galerie Pierre Colle in Paris, where he showed *The Persistence of Memory*. New York gallery owner Julien Levy bought the painting. Gala and Dalí took some time off with René Crevel in Port Lligat, where Crevel wrote *Dalí, or Anti-Obscurantism*. November saw the first Surrealist exhibition in the United States: "Newer Super-Realism" at the Wadsworth Atheneum (with de Chirico, Dalí, Ernst, Masson, Miró and Picasso). Les Éditions Surréalistes published Dalí's book *L'Amour et la Mémoire (Love and Memory)*, in which he wrote of his love for Gala.

> *Partial Hallucination. Six Apparitions*
> *of Lenin on a Grand Piano*
> *The Dream*
> *William Tell*
> *The Old Age of William Tell*

1932

Dalí took part in the exhibition "Surrealism: Paintings, Drawings and Photographs" at the Julien Levy Gallery in New York, and had his second solo show at the Galerie Pierre Colle in Paris. His book *Babaouo* (Éditions du Cahiers libres), in which he outlined his conception of cinema, was published shortly before Gala and Éluard were officially divorced. Dalí and Gala moved and spent the summer in Port Lligat, where René Crevel, André Breton and Valentine Hugo came to see them. In December, Dalí announced to the Viscount of Noailles the creation of the "Zodiac Group", a collective of friends who banded together to help Dalí financially by purchasing works from him on a regular basis.

> *Memory of the Child-Woman*
> *The Birth of Liquid Desires*
> *Fried Eggs on a Plate Without the Plate*
> *The Average Fine and Invisible Harp*

1933

Every month a member of the Zodiac Group would commission a painting, small or large, and at least two drawings from Dalí, often portraits of the buyer. Dalí signed a contract with Skira to illustrate the Comte de Lautréamont's *Les Chants de Maldoror*. Skira published the first issue of *Minotaure*; Dalí would be a diligent contributor for the thirteen issues. In June, he took part in a collective Surrealist exhibition at the Galerie Pierre Colle, which also hosted his third solo show. In August, Marcel Duchamp and Man Ray joined Dalí in Cadaqués to photograph Gaudí's work for *Minotaure*. Dalí had his first solo show at the Julien Levy Gallery in New York.

> *Gala and the Angelus of Millet Preceding*
> *the Imminent Arrival of the Conical*
> *Anamorphoses*
> *Portrait of Gala with Two Lamb Chops*
> *Balanced on Her Shoulder*
> *The Enigma of William Tell*
> *Geological Destiny*
> *The Invisible Man*

1934

Dalí and Gala (née Elena Ivanovna Diakonova) married in a civil ceremony, with Yves Tanguy and André Gaston as witnesses. Breton was unhappy with Dalí for expressing ideas out of line with Surrealist doctrine. Dalí took part in the "Exposition du Cinquantenaire of the Salon des Indépendants" at the Grand Palais in Paris without taking into account the opinion of other Surrealists who decided not to be part of the show. Breton tried to expel Dalí from the group – assembling, with the support of Brauner, Ernst and Tanguy, a jury to judge

him. Crevel, Tzara and Éluard opposed them. In the end, Dalí was "pardoned". *Les Chants de Maldoror* by Isidore Ducasse, Comte de Lautréamont, was published. It was one of the artist's major works: 42 etchings that took him two years. In October, Dalí had his first solo show in the UK at the Zwemmer Gallery in London. In November, he and Gala boarded the *Champlain* to make his first trip to the United States for his show at the Julien Levy Gallery. During his lecture for his exhibition at the Wadsworth Atheneum (Hartford, Connecticut), he uttered for the first time his celebrated line: "The only difference between me and a madman is that I'm not mad."

Atavism at Twilight
The Spectre of Sex Appeal
Atavistic Vestiges After the Rain
The Weaning of Furniture-Nutrition

1935

Before leaving New York, Dalí gave a lecture at MoMA: "Surrealist Painting and Paranoiac Images." Then he and Gala returned to Europe aboard the *Normandie*. In March, he was reunited with his family in Figueres; he hadn't seen his father for six years. A reconciliation took place. In June, his friend René Crevel committed suicide. Les Éditions Surréalistes published his book *La Conquête de l'Irrationnel*; the Julien Levy Gallery published the English version, *The Conquest of the Irrational*. In September, he met with Lorca, not knowing that this would be the last time he saw his poet friend alive. Dalí took part in the Surrealist exhibition at the Salle d'Exposition of the township of La Louvière in Belgium and the 1935 International Exhibition of Paintings at the Carnegie Institute in Pittsburgh. He provided illustrations for Paul Éluard's *Nuits Partagées*. His article "Picasso's Slippers", in which he applied his paranoiac-critical method to literature for the first time, appeared in *Les Cahiers d'Art*. It was actually almost identical to Sacher-Masoch's *Sappho's Slipper* (1859), which Dalí plagiarised by replacing Sappho's name with Picasso's.

The Horseman of Death
Face of Mae West Which May Be Used as an Apartment
The Angelus of Gala
Archaeological Reminiscence of Millet's Angelus

1936

In May, Dalí took part in the Exhibition of Surrealist Objects at the Galerie Charles Ratton in Paris, where he showed *Aphrodisiac Dinner Jacket* and *Monument to Kant*. In June, the New Burlington Galleries in London held an International Surrealist Exhibition and a series of lectures, the first by Breton and the last by Dalí, who chose to speak of paranoia, Pre-Raphaelites, Harpo Marx and ghosts, all while wearing a diver's helmet to show that his art penetrated the depths of the unconscious. He almost suffocated to death and had to stop mid-lecture. In London, he learned that the Spanish Civil War had begun, and that his close friend Federico García Lorca had died, a victim of Franco's regime. After taking some time off in Italy, he and Gala left for New York again, for Dalí was part of the "Fantastic Art, Surrealism, Dadaism" show at MoMA. For the occasion, Bonwit Teller department stores gave artists the opportunity to design Surrealist window displays; Dalí's in particular attracted attention. He had his third solo US show at the Julien Levy Gallery. In December, *Time* magazine devoted its cover to him, with photography by Man Ray: it was the beginning of his international fame. He had a correspondence with Harpo Marx, whom he greatly admired.

A Couple with Their Heads Full of Clouds

Lobster Telephone
The City of Drawers – Study for the
 "Anthropomorphic Cabinet"
Soft Construction with Boiled Beans
 (Premonition of Civil War)

1937

In February, Dalí went to Hollywood, where he met the Marx Brothers. He painted Harpo's portrait, and began to work with him on a script that was never produced. Then Gala and Dalí returned to Europe aboard the *Champlain*. Les Éditions Surréalistes published his poem "La Métamorphose de Narcisse", dedicated to Paul Éluard; the Julien Levy Gallery published the English version, "The Metamorphosis of Narcissus". On the cover was a photo of Dalí and Gala with *A Couple with Their Heads Full of Clouds*. This was, for Dalí, his first literary and artistic work produced by applying his paranoiac-critical method. At the Galerie Renou et Colle, he showed Harpo's portrait as well as *Face of Mae West Which May Be Used as an Apartment*, wherein he used the actress' face as the basis for a room and its furniture. In the same vein, he made *Mae West's Lips Sofa*. The Civil War prevented Gala and Dalí from going to Cadaqués, so Edward James invited them to Villa Cimbrone in Italy. Dalí concentrated on designing furniture, clothes and hats for Elsa Schiapaelli, some of which were made: the shoe hat, the India ink hat, the skeleton dress and the tears dress.

The Burning Giraffe
Metamorphosis of Narcissus
Sleep
Portrait of Freud

1938

17 January saw the inauguration at the Galerie des Beaux-Arts in Paris of the Exposition Internationale du Surréalisme, organised by André Breton and Paul Éluard, with Salvador Dalí's *Rainy Taxi* displayed at the entrance. Visitors then stepped into a "Surrealist street" where mannequins decorated by the artists – Duchamp, Miró, Dalí, Ernst and Man Ray, among others – stood about. Gala and Dalí went to Rome and Sicily, where the artist found himself confronted by memories of Catalonia and Africa. He painted *Impressions of Africa*. He took part in the exhibition "Trompe l'Oeil: Old and New" at the Julien Levy Gallery, and in the spring, in the International Exhibition of Surrealism at the Galerie Robert in Amsterdam. In London, Dalí visited Sigmund Freud and showed him *Metamorphosis of Narcissus* in the company of Stefan Zweig and Edward James. Zweig reported that while waiting to be introduced to the founder of psychoanalysis, Dalí drew a sketch that Zweig would never show to Freud, for the artist had intuitively spotted death in him (the doctor would die a year later).

Impressions of Africa
Apparition of Face and Fruit Dish on
 a Beach
The Sublime Moment

1939

Dalí was published in *Vogue*, where he identified himself as a "creator of jewels". Bonwit Teller in New York hired the artist to dress two of its windows. On opening day, Dalí noticed that the management had altered certain elements without notifying him, which sent him into a rage: he shattered the window and spent a few hours at the police station. In March, a new solo show at the Julien Levy Gallery was an immense success. He then signed an agreement with the World's Fair of New York to design a pavilion in which he would depict "an exploration of the desert of man's unsatisfied desires, and his dreams by day and by night". In July, he published the "Declaration of the Independence of the

Imagination and of the Rights of Man to His Own Madness" in reaction to the Surrealist committee's rejection of his idea to mount a Botticelli's *Venus* as a "reverse mermaid" with the head of a fish outside the pavilion. In *Le Minotaure*, André Breton's article "Latest Trends in Surrealist Painting" left out all mention of Dalí, a sign of how deep the rift was between them. The Spanish Civil War came to an end with Franco's victory. Dalí wrote to tell Buñuel that his father, marked by the sufferings of war, had become violently pro-Franco. When Dalí refused to give Buñuel money, their friendship came to an end. France entered the conflict that would become World War II. The Metropolitan Opera House in New York staged the first performance of the ballet *Bacchanale*, with libretto, costumes and sets by Dalí and choreography by Léonide Massine.

The Enigma of Hitler
Mad Tristan

1940

The revue *L'Usage de la Parole* published "Luminous Ideas: We Will Not Eat That Light", wherein Dalí outlined his interest in science, especially in Max Planck and quantum theory. German troops occupied Paris and invaded Bordeaux, where the Dalís had taken refuge. They emigrated to the US, where they remained for eight years. When they arrived, they moved in with Caresse Crosby at Hampton Manor in Virginia. Dalí worked on making an armchair that breathed, judging the world in need of more whimsy.

Old Age, Adolescence, Infancy
 (The Three Ages)
The Face of War

1941

The Philadelphia Museum of Art held an exhibition on art and advertising with Dalí, Picasso, Laurencin and O'Keeffe, among others. The Julien Levy Gallery threw the artist another solo show that also travelled to Los Angeles and Chicago. In its catalogue, Dalí published "The Last Scandal of Salvador Dalí", in which he explained his taste for the Renaissance and the importance of classicism: Vermeer, Raphael, Leonardo da Vinci, Vélasquez. *Vogue* published another article by Dalí, "Dream of Jewels", in which he addressed his collaboration with the Duke of Verdura. He also finished his autobiography *The Secret Life of Salvador Dalí*, published the next year by Dial Press. In September, the artist was given the task of decorating a masked ball at California's Del Monte Lodge: "A Surrealist's Night in an Enchanted Forest." As a wink to a 1938 installation by Marcel Duchamp, he hung 5,000 bags from the ceiling. The decorations represented the different states of drunkenness. In October, the ballet *Labyrinth* premiered at the Metropolitan Opera House in New York. In November, two major retrospectives opened at MoMA: one devoted to Dalí and another to Miró. That year, Dalí met Philippe Halsman, beginning a professional friendship that would continue right up to the photographer's death in 1979.

Invisible Bust of Voltaire
Soft Self-portrait with Fried Bacon
Labyrinth

1942

New York's Dial Press published *The Secret Life of Salvador Dalí*, an autobiography translated from the French by Haakon M. Chevalier with illustrations by the artist. The book reached number four in the January 1943 bestseller list. *Time* magazine named it "one of the most irresistible books of the year".

1943

Dalí took part in the exhibition "Early and Late"

at Peggy Guggenheim's Art of This Century gallery in New York. In the spring, Helena Rubinstein, also known as Princess Gourielli, commissioned him to decorate her apartment. He painted three panels representing the three times of day, an allegory of the three stages of life. He then proposed an exhibition of portraits at the Knoedler Gallery in New York, and wrote "From Dalí to the Reader" for the catalogue. In this essay, he listed everything he had undertaken since arriving in the US two and a half years earlier. In April, the Reynolds Morse couple purchased their first Dalí painting, *Daddy Longlegs of the Evening... Hope!* from George Keller of the Bignou Gallery. This was to be the start of a major collection of the painter's works. In May, Dalí designed a new ballet, *El Café de Chinitas*, based on a true story adapted by Federico García Lorca, which was performed in Detroit and at New York's Metropolitan Opera House.

> *The Poetry of America – The Cosmic*
> *Athletes*
> *Geopoliticus Child Watching the Birth*
> *of the New Man*

1944

Dalí exhibited at the "First Exhibition of Art of This Century in America" at the Art of This Century Gallery in New York and in "Religious Art of Today" at the Dayton Art Museum in Ohio. Dial Press published Dalí's first novel, *Visages Occultes* (*Hidden Faces*), a mélange of feelings, mysticism, history and fantasy. *Vogue* published the advertisements Dalí did in the course of three years for Bryans Hosiery. December saw the New York premiere by Ballet International of *Mad Tristan, The First Paranoiac Ballet on the Eternal Myth of Love in Death*. Dalí's plot was based on the musical themes of Wagner's *Tristan and Isolde*. In Dalí's conception, Tristan, driven mad by love, is slowly devoured by his transformed lover

Iseult Chimera, thus reenacting the tragic nuptial rites that can be observed in certain animal species.

> *Dream Caused by the Flight of a*
> *Bee Around a Pomegranate a*
> *Second Before Awakening*

1945

On 6 August, the US dropped the first atomic bomb on Hiroshima. Dalí began his nuclear and atomic period. His work in this period was driven by fear caused by the bombing. The artist went to Hollywood to work on the film *Spellbound* at the invitation of Alfred Hitchcock, who was greatly disappointed by the treatment of dream sequences in his films thus far and called upon Dalí to help with the first American film to deal with psychoanalysis, starring Gregory Peck and Ingrid Bergman. This artistic collaboration gave the film its incredible dream sequences. The Bignou Gallery opened the exhibition "Recent Paintings by Salvador Dalí". On this occasion, Dalí presented the first issue of *Dalí News*, which he published himself. It dealt solely with the artist and his oeuvre.

> *Galarina*
> *My Wife, Naked, Watching Her Own*
> *Body, Which Changes Into a Staircase,*
> *Three Vertebrae of a Column, the Sky*
> *And Architecture*
> *The Apotheosis of Homer*
> *Uranium and Atomica Melancholica*
> *Idyll*

1946

In January, he took part in a collective exhibition on the theme "The Temptation of Saint Anthony". He then showed 19 works at MoMA in "Four Spaniards: Dalí, Gris, Miró, Picasso". Walt Disney offered to have Dalí work on one of his productions entitled *Destino*, a short film from a team of animators. Dalí's

plan was to teach the greater public about Surrealism – a mission he believed would be more effectively carried out in animation than through painting or writing – by recounting the problems of life as confronted in the labyrinth of time. The film would not be shown until 2003. Dalí told his family he would soon return to Spain, but did not return until 1948. The Knoedler Gallery hosted "Dalí Presents a New Perfume", showing the three paintings of the Desert Trilogy that Dalí had done for the launch of Desert Flower perfume.

> *Giant Flying Demi-Tasse with*
> *Incomprehensible Appendage Five*
> *Metres Long*
> *The Temptation of Saint Anthony*

1947

Dalí provided illustrations for the revue *Script*. This allowed him to give his opinions of American cities and the atomic age, as well as give free rein to his concerns about the future. What would the world be like if we couldn't control atomic energy? What would the world be like if atomic energy controlled us? Between November and January, the Bignou Gallery featured him in two shows. He displayed his recent work, including studies for *Leda Atomica*. Attendees at the opening received the second and final issue of *Dalí News*, in which he announced that he would create an opera from scratch (he would never finish it) and that, at 44 years of age, it was time for him to realise his masterpieces – something that, according to him, he had begun to do with *Leda Atomica*.

> *Portrait of Picasso*
> *The Three Sphinxes of Bikini*

1948

In July, Dalí and Gala returned to Spain after eight years in the US. The newspaper *Destino* published "Bienvenido Salvador Dalí". As soon as they reached Port Lligat, the couple began work on plans to enlarge the house, buying a cabin on the highest part of the hill, which would become the library. In New York, Dial Press published *Cinquante Secrets Magiques pour Peindre* (*50 Secrets of Magic Craftsmanship*), in which Dalí sang the praises of Renaissance artists whom, as usual, he set up as the highest examples. In November, at the Teatro Eliseo in Rome, *Rosalinda o Come vi Piace* (Shakespeare's *Rosalind, or As You Like It*) premiered, directed by Luchino Visconti with sets and costumes by Dalí. The Galleria dell'Obelisco in Rome presented "The First Salvador Dalí Exhibition in Italy". Dalí worked with photographer Philippe Halsman on *Dalí Atomicus*. In this series of photos, Halsman managed to give the impression that the elements of *Leda Atomica* were levitating in mid-air.

1949

Dalí designed some sets and costumes for important shows: Richard Strauss' *Salomé* (book by Oscar Wilde, directed by Peter Brook) at Covent Garden in London, and José Zorrilla's *Don Juan Tenorio* at the Teatro Maria Guerrero in Madrid. Peter Brook was disappointed because Dalí did not go to London to oversee the realisation of his ideas in person. Dalí had an audience with Pope Pius XII and presented him with *The Madonna of Port Lligat*. The artist declared that his plan was to bring modern painting back into the wake of medieval art and the tradition of the Renaissance. From this time on, he spent all his springs and summers in Port Lligat, and divided his autumns and winters between the Hôtel Meurice in Paris and the St. Regis Hotel in New York. In the late 1940s, Dalí was deep in his mystical and nuclear period – see *The Mystical Manifesto* (1951) – characterised

by religious and scientific themes (nuclear fission and fusion). In December, Anna Maria Dalí published *Salvador Dalí Visto por su Hermana* (*Salvador Dalí as Seen by his Sister*), much to his displeasure, for he had no say in or control over the book.

Leda Atomica
The Madonna of Port Lligat
　　(first version)

1950

In reaction to his sister's account, he wrote a memorandum to warn the public that her book was full of errors. He continued his work on expanding the house at Port Lligat and built a place for Gala during this period: a former boat converted into a house, a foretaste of their future home in Púbol. In an interview with *Destino*, he indirectly explained his Catholic faith and classicism. A new edition of Breton's *Anthology of Black Humour* was published; Breton used the occasion to add a passage clearly stating that he had seriously distanced himself from the painter, whom he nicknamed "Avida Dollars" (an anagram hinting at what he saw as the artist's greed). Above all, Breton violently rejected Dalí's new religious faith. Salvador Dalí i Cusí, the artist's father, died in September. The MoMA organised the exhibition "The Artist and Decorative Arts", in which Dalí appeared beside Calder, Matta, Moore, Gris, Noguchi and O'Keeffe. In October, he gave a lecture at Barcelona's Ateneu entitled "Why I Was Sacrilegious, Why I Am Mystical", in which he explained his affiliation with the Spanish mystic tradition (St. John of the Cross, Zurbarán). He showed two versions of *The Madonna of Port Lligat* at the Carstairs Gallery in New York and supplied an article of the same name for the catalogue.

Landscape of Port Lligat
The Madonna of Port Lligat
　　(second version)

1951

In Paris, Michel Tapié and Robert J. Godet published *The Mystical Manifesto* in a limited edition with red velour covers and gilded letters, the body of the text divided into two columns: one French, one Latin. This manifesto was the artist's transcendental explanation of his admiration for the Renaissance, classicism and religious painting, his preferred themes in recent years. In May, Dalí was invited to the First Bienal Hispanoamericana de Arte, organised by the Spanish Cultural Institute at the Museo de Amigos de Arte in Madrid. Dalí exhibited 32 works. In November, he gave a talk entitled "Picasso and I" at Madrid's Teatro María Guerrero, in which his aim was to show that the main difference between them was one of political orientation. According to Dalí, Picasso was a communist, which he strongly deplored – Dalí had turned toward Francoism at the time – although they had many things in common: they were both Spanish, were geniuses and were known throughout the world. In December, the Lefevre Gallery in London devoted a special exhibition to Dalí.

Raphaelesque Head Exploding
Christ of St. John of the Cross

1952

Dalí embarked on a lecture tour about his nuclear mysticism across the US. He also wrote many articles in French, such as "Authenticity and Lies", to establish his disagreement with social realism. The University of Texas published "The Myth of William Tell: The Whole Truth about my Expulsion from the Surrealist Group". In the Catholic journal *Études Carmélitaines* (*Carmelite Studies*), Dalí published "Reconstitution of the Glorious Body in the Sky", in which he declared that the Assumption of the Virgin Mary would be physically impossible according to Dalínian

mysticism. In November, his close friend Paul Éluard died. For the catalogue of his exhibition that year at the Carstairs Gallery, he wrote the article "Long Live Modern Art on the Basis of Painting According to Raphael".

Assumpta Corpuscularia Lapislazulina
Galatea of the Spheres

1953

In his article for the magazine *Connaissance des Arts*, Dalí explained his painting to the public ("Notes on the *Assumpta Corpuscularia Lapislazulina*"). In April, Enrico Baj accused Dalí of not having invented "nuclear painting".

1954

In February, the magazine *La Parisienne* published Dalí's piece on the deaths of Federico García Lorca and René Crevel, "Me and the Dead Men" (later reprinted in *Diary of a Genius*). In May, at the Casino dell'Aurora in the Palazzo Pallavicini in Rome, he exhibited his illustrations for Dante's *The Divine Comedy* as well as jewellery from the Catherwood collections. Before the show's opening, Dalí died symbolically in order to be reborn from a "metaphysical cube" or "bucket" that represented, according to the artist, the greatest spiritual force humankind had invented. This was an homage to Goethe, who, upon reaching Rome, said, "I feel myself being reborn." The exhibition then travelled to Venice and Milan; it was a great success. The fruit of Dalí's collaboration with Philippe Halsman, a book of photos entitled *Dalí's Mustache*, was published. Dalí had a new solo show at the Carstairs Gallery in New York. He provided illustrations for *La Verdadera Historia de Lidia de Cadaqués* (*The True Story of Lídia of Cadaqués*) by Eugeni d'Ors, published by José Janés.

The Disintegration of the Persistence

of Memory
Crucifixion ("Corpus Hypercubus")
Dalí Nude, in Contemplation Before the
* Five Regular Bodies Metamorphised*
* into Corpuscles, in Which Suddenly*
* Appears the Leda of Leonardo*
* Chromosomatised by the Visage of*
* Young Virgin Gala Sodomised by the*
* Horns of Her Own Chastity*

1955

During the summer, Dalí worked on *The Last Supper*. He also painted *Portrait of Laurence Olivier in the Role of Richard III* to promote the film *Richard III*, based on the work by Shakespeare and directed by Alexander Korda. He created a paranoiac-critical interpretation of Vermeer's *The Lacemaker*, going inside the rhinoceros pen at the zoo in Vincennes in order to do so. His film on the same subject never sees the light of day (*The Miraculous Story of the Lacemaker and the Rhinoceros*). In December, he gave a talk at the Sorbonne entitled "The Phenomenological Aspects of the Paranoiac-Critical Method".

The Last Supper
The Lacemaker (copy of the painting by
* Vermeer)*

1956

Chester Dale, a major collector of Dalí's works, donated *The Last Supper* to the National Gallery in Washington, DC (he had done the same the year before, giving *Corpus Hypercubus* to the Met in New York). In June, Dalí met Franco. He paid homage to Gaudí, whom he had always ranked among the essential artists, by giving a talk at Park Güell in Barcelona. The funds collected during this performance, which featured him creating a work live, went to the organisation in charge of preserving Gaudí's works and completing the Sagrada Familia. At the end of the year,

he had a show at the Carstairs Gallery in New York. He also made lithographs live in public for *Histoire d'un Grand Livre – Don Quichotte* (*History of a Great Book – Don Quixote*), to be published by Joseph Foret.

Nature Morte Vivante (Living Still Life)
Rhinocerotic Gooseflesh
Anti-Protonic Assumption

1957

Dalí took part in the exhibition "Bosch, Goya and the Fantastic" at the Festival of Bordeaux. In the magazine *Nugget*, he began a series of predictions about the future: for instance, future furniture would be soft and flexible, sofas would breathe and spoons would be gelatinous. Walt Disney came to see him at Port Lligat, and they decided to collaborate on a project based on *Don Quixote*. This never came to pass. Joseph Foret*'s Histoire d'un Grand Livre – Don Quichotte*, with fifteen lithographs by Dalí, was published, containing a description of the process of the book's creation.

Celestial Ride
Sorcery – The Seven Arts
Santiago El Grande

1958

Hoechst Ibérica commissioned a holiday greeting card for Spanish doctors and scientists. His collaboration with the company was to last for nineteen years. In late January, MoMA organised an homage to Gaudí, yet another occasion for Dalí to express his admiration for the architect and address his detractors. In May, he created a twelve-metre baguette in Paris to promote his talk at the Théâtre de l'Étoile. On 8 August, Dalí and Gala were married at the Els Àngels shrine in Sant Martí Vell, near Girona. During an "atomic-nuclear" cocktail party at the Eiffel Tower, the Cuban ambassador gave the artist an honorary

award. To commemorate the occasion, a giant ear – a "papal" ear, according to Dalí – was hung from the tower's first floor. He dedicated his show at the Carstairs Gallery to his wife, and published his "Antimatter Manifesto" in the catalogue.

The Sistine Madonna
Meditative Rose
Ascension

1959

Dalí met Pope John XXIII and informed him of his desire to build a church in the Arizona desert to pay tribute to the success of the ecumenical council. Then he gave a talk at the Bal des Petits Lits Blancs (Little White Beds' Ball, a charitable organisation for orphans) in Paris, which gave him a great deal of pleasure, for the audience was, according to him, more Dalínian than he was. In December, he presented his new means of transport in New York: the ovociped, a plexiglass sphere propelled by a seated occupant. He donned a gold suit for the occasion.

The Discovery of America by Christopher Columbus
The Virgin of Guadalupe

1960

Dalí premiered the documentary *Chaos and Creation*, in which he produced a painting in fifteen minutes, and was also seen at work with photographer Philippe Halsman and musician Lleonar Balada. Joseph Foret published an edition of *The Divine Comedy* with watercolours by Dalí, a commission from the Italian government to commemorate the anniversary of Dante's death. Dalí announced that the Vatican had commissioned a painting depicting the mystery of the Holy Trinity, to be displayed at the next ecumenical council. In a piece entitled "Velázquez the Pictorial Genius", he paid homage to Velázquez in

the catalogue for the exhibition "O Figura. Homenaje Informal à Velázquez" ("Oh, Figure: Informal Homage to Velázquez") at the Sala Gaspar in Barcelona. In November, Marcel Duchamp, André Breton, Édouard Jaguer and José Pierre opened the exhibition "Surrealist Intrusion in the Enchanter's Domain" at the D'Arcy Galleries in New York. The Surrealists published a pamphlet to protest Dalí's presence in the show, entitled "We Don't EAR it that Way." He finished off the year with another show at the Carstairs Gallery, this time of watercolours, including *The Enigma of William Tell* (1933) and his latest, *The Ecumenical Council*.

San Salvador and Antonio Gaudí
 Fighting for the Crown of the Virgin
Pieta. From "The Apocalypse of St. John"
Gala Nude From Behind Looking in an
 Invisible Mirror
The Ecumenical Council
Chaos and Creation

1961

Figueres' new mayor, Ramón Guardiola, entered office and immediately set the necessary administrative machinery in motion to pay homage to Dalí with what would become the Dalí Theatre-Museum. In August, his hometown paid tribute with a series of events including a bullfight. Nikki de St. Phalle and Tinguely created a giant golden plaster bull for Dalí. At the same time, the Teatro La Fenice in Venice gave the first performance of *La Dama Spagnola e il Cavaliere Romano* (*The Spanish Lady and the Roman Gentleman*), with music by Scarlatti and five stage sets by Dalí, followed by the ballet *Gala*, with choreography by Maurice Béjart and sets and costume by Dalí. In September, Dalí's appearance on the French TV show *Gros Plan* (*Close-Up*) was censored by Raymond Janot, CEO of RTF

(Radiodiffusion-Télévision Française), because of Dalí's remarks on masturbation. He gave a talk at the École Polytechnique in Paris called "Gala Deoxyribonucleic Acid".

 Mohammed's Dream (Homage to
 Fortuny)

1962

La Dama Spagnola e il Cavaliere Romano toured Paris and Brussels. For *Art News*, Dalí wrote the article "Tàpies, Tàpies, Classic, Classic!" in which he compared the artist to Vélasquez, paying special attention to the fact that they used the same range of colours. Dalí also paid tribute to another artist, Mariano Fortuny, during Barcelona's Saló del Tinell, writing an article for the catalogue entitled "Fortuny, Dalí and his Tétouan Battles". He donated his *Christ of the Vallès* for a sale and exhibition of works to raise money for the victims of that year's September floods in the Vallès region near Barcelona.

 The Battle of Tetuan

1963

The Gallery of Modern Art in New York bought *The Battle of Tetuan*; Dalí wrote a two-part article for *Show* consisting of "A Manifesto" and "Dalí's Notes on *The Battle of Tétouan*" in which he explained that this little-known battle from 1859–60 was a major transcendental event. The canvas was a colossal work for the artist, who spent two years on it, using various complicated techniques. In October, Jean-Jacques Pauvert published a Dalí piece that had been missing for twenty-two years: *Le Mythe Tragique de "L'Angélus" de Millet. Interprétation Paranoïaque-Critique* (*The Tragic Myth of Millet's "Angelus": Paranoiac-Critical Interpretation*), in which Dalí explained that instead of peasants praying in the painting, he saw a couple burying their child. Dalí

had an x-ray analysis done at the Louvre, which indeed revealed a dark stain at the spot in question, which reassured the artist in his interpretation. For the exhibition "Homage to Crick and Watson" at the Knoedler Gallery in New York, he showed *GALACIDALACIDESOXYRIBONU-CLEICACID*, his work with the longest single-word title. Dalí declared that the train station in Perpignan was the centre of the cosmic world: "At the station in Perpignan, I experienced a kind of cosmogonic ecstasy stronger than any that had come before. I had an exact vision of the constitution of the universe. The universe, which is one of the most limited things in existence, would, all proportions being equal, be similar in structure to the Perpignan railway station." (*Diary of a Genius*)

Portrait of My Dead Brother

1964

Dalí was present in the Spanish and French pavilions of the World's Fair in New York. In September, a major retrospective exhibition opened at the Tokyo Prince Hotel with 103 of his works. In November, he was awarded the Gran Cruz de Isabel la Católica, the highest Spanish distinction. The Moderna Museet in Stockholm purchased *The Enigma of William Tell*, thanks to Marcel Duchamp.

Venus with Drawers

1965

Andy Warhol began his screen tests with Dalí. In the fall, Dalí met Amanda Lear, who became one of his closest friends for many years. They spent a great deal of time together in Paris, New York and Port Lligat, where she frequently posed for him and participated in several of his performances. The Gallery of Modern Art in New York organised one of the more important Dalí retrospectives to date,

"Salvador Dalí 1910–1965." In December, with the publication of *Diary of a Genius*, Dalí strode down Fifth Avenue dressed as Santa Claus for a signing at Doubleday Books.

The Railway Station at Perpignan
Homage to Meirronier

1966

Over the course of this year and the next, Dalí painted *Tuna Fishing*, a very important painting in his oeuvre as it united several styles: op art, pop art, pointillism, action painting, psychedelic art and *l'art pompier*. In collaboration with Dalí, Jean-Christophe Averty made the documentary *Autoportrait Mou de Salvador Dalí* (*Soft Self-Portrait of Salvador Dalí*, 52 mins.), which was shown at the same time on television and in movie theatres. But the film was banned for violence in the US. Dalí took part in the exhibition "Surrealism: A State of Mind", organised by the University of California, Santa Barbara.

1967

The Louisiana Museum of Modern Art in Humlebæk, Denmark, hosted "Zie Surrealistische Schilders" ("Six Surrealist Painters") featuring works by Dalí, Delvaux, Ernst, Magritte, Miró and Tanguy (the exhibition toured the Palais de Beaux-Arts in Brussels). *Arts Magazine* published his article "How an Elvis Presley Becomes a Roy Lichtenstein", in which he sang the pop artist's praises. Raymond de Becker published *The Tragic Life of Sigmund Freud* with a portrait of the psychoanalyst by Dalí on the cover. In the salons of the Hôtel Meurice in Paris, Dalí organised the exhibition "Hommage à Meissonier", in which he presented the work *Tuna Fishing*. In December, the Sidney Janis Gallery gathered a number of artists, including de Kooning, Warhol, Cartier-Bresson and Dalí, for an "Homage to Marilyn Monroe". Dalí

presented a *Self-Portrait* in which Marilyn's features are combined with those of Mao Zedong.

Tuna Fishing (Homage to Meissonier)

1968

Dalí took part in the exhibition "Dada, Surrealism and their Heritage" at MoMA in New York, creating the posters and displaying eleven works. The year also saw the publication of the monograph *Dalí de Draeger*, for which the painter wrote the prologue. The book was divided into nine themes: war, landscape, Gala, daily life, eroticism, mysticism, space-time, oneirism and imperial classicism. In June, the Fondation Paul Ricard acquired *Tuna Fishing*. In an interview, Dalí explained that this work took into account one of his first dreams as a child: his father was telling him a story, and he had been deeply disturbed by an engraving depicting it. In his painting, Dalí evoked the struggle between man and animal, allegorising the origins of our subconscious in the sea's mysterious abysses. Dalí was immortalised in a wax statue at the Musée Grévin, beside Brigitte Bardot and Françoise Sagan. He recorded an ad for Lanvin chocolates in which his moustache was exploited to comic effect.

1969

Dalí purchased the Castell de Púbol and decorated it for Gala. In *Art News*, he wrote "De Kooning's 300,000,000th Birthday", in which he called him one of the most gifted and most authentic of modern artists. Over the course of the 1960s and 1970s, Dalí grew increasingly interested in science and holography, which offered him new perspectives in his constant quest to master three-dimensional images. More specifically, he studied processes that might give viewers an impression of plasticity and space; with the third dimension, he aspired to gain access to the fourth – namely immortality.

The Cosmic Athlete

1970

He held a press conference at the Gustave Moreau Museum in Paris, in which he announced the founding of the Dalí Theatre-Museum in Figueres. Renovations continued at Púbol Castle: Dalí designed fireplaces and some furniture. Sculptures of long-legged elephants were placed about the property. In November, the Museum Boijmans van Beuningen in Rotterdam premiered the largest European retrospective devoted to Dalí thus far. Two hundred works were on display: oil paintings, drawings, watercolours, jewellery, sculptures, etc. The following year, the exhibition travelled to the Staatliche Kunsthalle in Baden-Baden (Germany).

The Hallucinogenic Toreador

1971

In memory of his friendship with Marcel Duchamp, Dalí designed a silver chess set for the American Chess Foundation. March saw the inauguration of the Salvador Dalí Museum in Cleveland, Ohio, to house the A. Reynolds and Eleanor Morse collection. He also published his novel *Procès en Diffamation Plaidé devant la Conférence du Stage* (*Libel Suit Pleaded Before the Association of Young Lawyers in Charge of Emergency Criminal Defense*), the story of a man charged with defamation for having claimed he feigned his paranoia.

1972

In March, Dalí took part in "Der Surrealismus 1922–1942" at the Haus der Kunst in Munich; the exhibition later travelled to the Musée des Arts Décoratifs in Paris. In April, the Knoedler Gallery in New York presented

the world's first exhibition of holograms, which Dalí had created in collaboration with Dennis Gabor, a Nobel laureate for his research on lasers. Holography was a new art form based on the latest optical technology. Jean-Christophe Averty's documentary *Autoportrait Mou de Salvador Dalí* (*Soft Self-Portrait of Salvador Dalí*) opened in theatres. In the press kit, Dalí expressed his doubts as to the film's ability to give an exact account of his real and imaginary worlds.

Self-Portrait (Mao-Marilyn)

1973

Dalí was made a member of the Real Academia de Bellas Artes di San Fernando in Madrid. In April, the Knoedler Gallery in New York dedicated one of its rooms to Dalí's holographs. He decided to display *Alice Cooper's Brain* as a tribute to the rock star, who often appeared onstage in makeup with a snake around his neck. On 8 April, Picasso died; Dalí wrote an article for *Paris Match*, "Picasso and Horsehairs". In May, his book-object *Dix Recettes d'Immortalité* (*Ten Recipes for Immortality*) was published. In its ten chapters, the artist examined problems posed by life and death, the finite and the infinite. The book begins with these words: "The best recipe for immortality is a gift from God: faith." Around the same time, he gave a talk at the Sala Velázquez in the Museo del Prado in Madrid, entitled "Velázquez and I", in which he stated that the halls of his museum in Figueres would host other things besides paintings (performances, lectures) and that what would count the most was conversing with the public. In *Paris Match*, he published "Dalí's Six Days", in which he described his daily life and creative process. In a piece for *La Vanguardia*, "Painting and Photography. Hyperrealism and Monarchy", he claimed to be flattered to hear people say that his paintings looked like photos

at first glance, but better. Draeger published *Les Dîners de Gala* (*Gala's Dinners*), which features 55 recipes, including 21 from famous chefs. The book is divided into twelve chapters: "The Cannibalisms of Autumn", "Pâtés Made from Liliputian Malaises", "Sodomised Between Courses", etc.

> *Dalí from the Back Painting Gala from the Back Eternalised by Six Virtual Corneas Provisionally Reflected in Six Real Mirrors*
> *Gala's Foot*
> *Hitler Masturbating*

1974

Dalí wrote the prologue to the book *Difficult Death* by René Crevel. In August, he was the central figure of a happening organised by the Vallès County Initiatives and Tourism Centre in Granollers (Barcelona Province), produced by the German television channel that worked on the artist's film *Impressions de la Haute Mongolie* (*Impressions of Upper Mongolia*). But the year was dominated by the inauguration of the Dalí Theatre-Museum in Figueres, which opened on 28 September. Many of his works can be found there, of course, but also works by other artists (Fuchs, Fortuny, El Greco, Pitxot). Dalí also wrote the preface to a monograph on Antoni Pitxot, who was also the Theatre-Museum's director. He prefaced and illustrated Sigmund Freud's book *Moses and Monotheism*.

1975

In January, the film *Dalí: Impressions de la Haute Mongolie* (*Dalí: Impressions of Upper Mongolia*), directed by José Montes Baquer, was shown at the International Fantastic Film Festival in Avoriaz, France. It is the story of a quest for a hallucinogenic mushroom. The Dalí Theatre-Museum and the Salvador Dalí Museum in Cleveland jointly released a

previously unpublished work: Dalí's opuscule *Eroticism in Clothing*, entirely dictated to A. Reynolds Morse in 1963.

> *Gala Contemplating the Mediterranean Sea Which at Twenty Metres Becomes the Portrait of Abraham Lincoln – Homage to Rothko (first version)*

1976

Dalí published two issues of *Setmanari Artístic Mar Empordanesa*, the Dalí Theatre-Museum's news bulletin, in which he spoke of his work and the museum. In August, he gave drawing lessons with Pitxot's assistance; hundreds of students and artists signed up. He used automatic writing directed by alliteration to write *T*, which would be published in 1979. Dalí created some racy ads for Perrier.

> *Gala Contemplating the Mediterranean Sea Which at Twenty Metres Becomes the Portrait of Abraham Lincoln – Homage to Rothko (second version)*
> *Retrospective Bust of a Woman*

1977

The Musée Castres (now the Musée Goya) presented the exhibition "Homage to Goya" featuring 81 of Dalí's etchings in the style of Goya. To show his support for the Sant Andreu de Barcelone soccer team, which was having financial woes, he painted *Goal*. Draeger published *Les Vins de Gala* (*Gala's Wines*), in which Dalí listed the couple's favourite wines. The book won the Prix Montesquieu for the Art of the Sommelier in France. For the 50th anniversary of Gaudí's death, Dalí designed the cover for a small book devoted to completing the crypt at the Colonia Güell in Santa Coloma de Cervelló.

> *Dalí Lifting the Skin of the Mediterranean Sea to Show Gala the Birth of Venus*

1978

The Spanish royal family visited the Dalí Theatre-Museum, guided by the artist and his wife. The Salvador Dalí museum in Beachwood, Ohio, opened the exhibition "Dalí & Halsman". At the Solomon R. Guggenheim Museum in New York, Dalí presented his first hyperstereoscopic painting, *Dalí Lifting the Skin of the Mediterranean to Show Gala the Birth of Venus*.

> *Gala's Christ*
> *The Harmony of the Spheres*

1979

Dalí was appointed associate overseas member of the Académie des Beaux-Arts of the Institut de France. To celebrate his 75th birthday and the nomination, Radio Television Española aired a three-part story on the artist, hosted by Paloma Chamorro, with footage from a two-day interview Dalí gave at the St. Regis Hotel in New York. In November, the artist gave King Juan Carlos *The Prince of Sleep*, a large portrait of the king several years in the making. In December at the Georges-Pompidou Centre in Paris, the most ambitious Dalí retrospective to date opened, conceived and designed by the artist. The exhibition was divided into eleven sections: early works, *Un Chien Andalou*, Surrealist works, *les oeuvres douces* (soft works), William Tell, double images, Angelus and Maldoror, Surrealist objects, dreams and nightmares 1936–38, mysticism and science and stereoscopy.

> *The Prince of Sleep*

1980

Dalí convalesced at Port Lligat for the entire year. From 14 May to 29 June, the Pompidou Centre's retrospective travelled to London's Tate Gallery, with a total of no less than two hundred and fifty-one works on show (oil paintings and drawings).

1981

The Dream (1937), from the collection of Edward James, was sold for £360,000, setting the record for the sale of a work by a living artist. In August, the king and queen of Spain visited Dalí in Port Lligat. The Centre for Tourism in Vallès celebrated its 10th anniversary by paying homage to the artist at the Dalí Theatre-Museum in Figueres. It was an occasion for the artist to review the many twists and turns of his life: at first spurned by the Real Academia de Bellas Artes, his family and the Surrealists, before finally being taken back in by all who had turned their backs on him. He also recalled the incredible adventure that was the construction of Port Lligat, from the days when it was a humble fisherman's hut he'd bought for Gala at a price of 500 pesetas.

The Path of Enigmas
The Pearl

1982

In February, a Dalí retrospective toured Japan (Isetan Museum of Art, Tokyo; Daimaru Museum, Osaka; Kitakyushu Municipal Museum of Art). In March, the Salvador Dalí Museum, founded by Eleanor and A. Reynolds Morse, was inaugurated in St. Petersburg, Florida. On 10 June, Gala died in Port Lligat; the same day, her coffin was transferred to the crypt in the Castell de Púbol, which Dalí had built for that express purpose. He moved to the château, but continued to travel back and forth from Port Lligat. King Juan Carlos I of Spain appointed Dalí Marquis of Púbol. In September, Dalí gave *The Three Glorious Enigmas of Gala*, which he had painted a few months before his wife's death, to the nation of Spain. Other works already in the nation's possession were *Harlequin* (1926) and *Cenicitas* (*Little Ashes*, 1927–28), which were acquired in June for 100 million pesetas.

Pieta
The Three Glorious Enigmas of Gala

1983

Dalí finished his final work, *The Swallow's Tail – Series of Catastrophes*, inspired by the theories of mathematician René Thom. The first major Spanish retrospective, "400 Works by Salvador Dalí from 1914 to 1983", was held in Madrid by the Cultural Department of the Government of Catalonia and the Ministry of Culture. It later toured Barcelona and Figueres. In October, Dalí began designs for restructuring the façade of the Torre Gorgot de Figueres, a tower just beside the Dalí Theatre-Museum. The artist renamed it the Torre Galatea in memory of his wife. The Fundación Gala Salvador Dalí was created in Figueres.

The Swallow's Tail – Series of
Catastrophes

1984–1989

The Civic Gallery of Modern and Contemporary Art at the Palasso dei Diamanti in Ferrara hosted a major retrospective exhibition, "Dalí by Salvador Dalí", featuring 248 works. A fire destroyed part of the Castell de Púbol. Dalí was wounded and moved permanently to the Torre Galatea, Figueres, where he remained until his death on 23 January 1989.

Selected Bibliography

WRITINGS BY SALVADOR DALÍ

The Secret Life of Salvador Dalí, trans. Haakon M Chevalier. New English Edition, London: Vision, 1961. Dover Publications, 2013.

The Tragic Myth of Millet's "Angelus": Paranoiac-Critical Interpretation Including the Myth of William Tell, trans. Albert Reynolds Morse. St. Petersburg, Fla.: Salvador Dalí Museum, 1986.

Diary of a Genius, trans. Richard Howard. New York: Doubleday, 1965.

Oui. La Revolution Paranoïaque-Critique. L'Archangélisme Scientifique [1971]. Paris: Denoël/Gonthier, 2004.

Journal d'un Génie Adolescent [1919-1920], trans. from Catalan by Patrick Gifreu, preface and notes by Félix Fanés. Monaco: Le Rocher, coll. «Anatolia», 2000.

Obra Completa volume I. Textos autobiograficos 1, Félix Fanés (dir.), Figueres, Destino/Fundació Gala-Salvador Dalí, 2003.

Obra Completa volume II. Textos autobiograficos 2, Montse Aguer (dir.), Figueres, Destino/Fundació Gala-Salvador Dalí, 2003.

Obra Completa volume III. Poesía, Prosa, teatro y cine, Agustin Sanchez Vidal (dir.), Figueres, Destino/Fundació Gala-Salvador Dalí, 2004.

Obra Completa volume IV. Ensayos 1, Juan José Lahuerta (dir.), Figueres, Destino/Fundació Gala-Salvador Dalí, 2005.

Obra Completa volume V. Ensayos 2, Juan Manuel Bonet (dir.), Figueres, Destino/Fundació Gala-Salvador Dalí, 2005.

Obra Completa volume VI, Figueres, Destino/Fundació Gala-Salvador Dalí, 2006.

Obra Completa volume VII. Entrevistas, Francisco Calvo Serraller (dir.), Figueres, Destino/Fundació Gala-Salvador Dalí, 2006.

La Vie Secrète de Salvador Dalí: Suis-je un Génie? Critical edition established by Frédérique Joseph-Lowery. Lausanne: L'Âge d'homme, 2006.

L'Esputnic du Paubre. Paris: La Table ronde, 2008.

REFERENCE WORKS AND MONOGRAPHS

Ades, Dawn. *Dalí*. London: Thames & Hudson, 1982.

Ades, Dawn. *Dalí*. Barcelona: Folio, 1983.

Ades, Dawn. *Dalí*. New York: Thames & Hudson, 1988.

Aguer, Montserrat. *The Treasures of Dalí*, trans. Matthew Clarke. London: Goodman, 2009.

Descharnes, Robert. *Salvador Dalí: The Work, The Man*. New York: H.N. Abrams, 1984.

Fanés, Fèlix. *Salvador Dalí: The Construction of the Image, 1925-1930*. New Haven: Yale University Press, 2007.

Gaillemin, Jean-Louis. *Dalí: The Impresario of Surrealism*. London: Thames and Hudson, 2004.

Gibson, Ian. *The Shameful Life of Salvador Dalí*. London: Faber & Faber, 1997.

Hine, Hank, Jeffett, William, and Reynolds, Kelly. *Persistence and Memory: New Critical Perspectives on Dalí at the Centennial*. St. Petersberg (Florida): Bompiani/The Salvador Dalí Museum, 2004.

Millet, Catherine. *Dalí and Me*. Zurich: Scheidegger & Spiess, 2008.

Minguet Batllori, Joan M. *El Manifesto Amarillo: Dalí, Gasch, Montanya, y el Antiarte*. Barcelona: Galaxia Gutenberg, 2004.

Rodrigo, Antonina. *Lorca Dalí: Una Amistad Traicionada*. Barcelona: Planeta, 1981.

Rojas, Carlos. *Salvador Dalí, or The Art of Spitting on Your Mother's Portrait*. University Park, Pa.: Pennsylvania State University Press, 1993.

Romero, Luis. *Dalí*. Seacaucus: Chartwell Books, Inc., 1979.

Ruffa, Astrid, Kaenel, Philippe and Chaperon, Danielle. *Salvador Dalí à la croisée des savoirs*. Paris: Desjonquères, 2007.

Ruffa, Astrid. *Dalí ou le dynamisme des formes*. Dijon: Les Presses du réel, 2009.

Sanchez-Vidal, Agustín. *Buñuel, Lorca, Dalí. El Enigma sin fin*. Barcelona: Planeta, 1996.

Sanchez-Vidal, Agustín, Maurer, Christopher, Gubern, Román (et al). *Ola Pepín! Dalí, Lorca y Buñuel en la Residencia de Estudiantes*. Barcelona/Madrid: Fundació Caixa Catalunya/Publicaciones de la Residencia de Estudiantes, 2007.

Santos Torroella, Rafael. *La miel es más dulce que la sangre. Las épocas lorquiana y freudiana de Salvador Dalí*. Barcelona: Seix Barral, 1984.

Santos Torroella, Rafael. *Salvador Dalí, Federico García Lorca. Correspondance 1925–1936*. Paris: Carrère, 1987.

Santos Torroella, Rafael. *Dalí residente*. Madrid: Publicaciones de la Residencia de Estudiantes, 1992.

Dalí, época de Madrid [catalogue raisonné]. Madrid: Publicaciones de la Residencia de Estudiantes/Ayuntamiento de Madrid, Área de las Artes, 1994.

RECENT EXHIBITION CATALOGUES

Dalí joven (1918–1930). Madrid/Figueres/London/New York: Museo Nacional Centro de Arte Reina Sofía/Fundación Gala-Salvador Dalí/The South Bank Centre/The Metropolitan Museum of Art, 1994.

El país de Dalí. Figueres/Barcelona: Museu de l'Empordà/Museu d'Història de Catalunya, 2004.

Ades, Dawn (dir.). *Dalí's Optical Illusions*. London/New Haven: Wadsworth Atheneum Museum of Art/Yale University Press, 2000.

Ades, Dawn and Bradley, Fiona (dir.). *Salvador Dalí. A Mythology*. Liverpool/St. Petersberg (Florida): Tate Gallery/Salvador Dalí Museum, 1999.

Ades, Dawn, Taylor, Michael R., Aguer, Montse (dir.). *Dalí*. New York/Philadelphia: Rizzoli/Philadelphia Museum of Art, 2004.

Bermejo de Santos Torroella, María Teresa and Mas Peinado, Ricard (dir.). *El primer Dalí, 1918–1929* [catalogue raisonné]. Valencia/Madrid: Institut Valencià d'Art Modern/Publicaciones de la Residencia de Estudiantes, 2005.

Fanés, Félix (dir.). *Dalí, cultura de masses*. Madrid/Barcelona/Figueres: Sociedad Estatal de Conmemoraciones/Museo Nacional Centro de Arte Reina Sofía/Fundación Caixa de Catalunya/Fundació Gala-Salvador Dalí, 2004; English version, *It's All Dalí*. Rotterdam: Museum Boijmans Van Beuningen, 2005.

Gale, Matthew (dir.). *Dalí & Film*. London: Tate Modern, 2007.

King, Elliott H., Aguer, Montse, Hine, Hank and Jeffett, William. *Dalí, the Late Work*. New Haven/Atlanta: Yale University Press/The High Museum of Art, 2010.

Lahuerta, Juan José (dir.). *Dalí architecture*. Barcelona: La Pedrera/Fundació Caixa de Catalunya, 1996.

Lahuerta, Juan José (dir.). *Dalí, Lorca y la Residencia de Estudiantes*. Madrid: Caixa Forum, 2010, vols I and II.

Lahuerta, Juan José (dir.). *Dalí, Lorca y la Residencia de Estudiantes*. Madrid: Fundación La Caixa/Sociedad Estatal de Conmemoraciones Culturales, 2010.

von Maur, Karin. *Salvador Dalí 1904–1989*. Staatsgalerie Stuttgart/Kuntshaus Zürich, 1989; reissued, Stuttgart: Verlag Gerd Hatje, 1994.

Also available in the **ART MASTERS** series:

<table>
<tr><td>PABLO</td><td>VINCENT</td><td>MUNCH</td></tr>
<tr><td>by Julie Birmant and
Clément Oubrerie</td><td>by Barbara Stok</td><td>by Steffen Kverneland</td></tr>
</table>

PABLO	VINCENT	MUNCH
by Julie Birmant and Clément Oubrerie	by Barbara Stok	by Steffen Kverneland
ISBN 978-1-906838-94-2	ISBN 978-1-906838-79-9	ISBN 978-1-910593-12-7
Paperback, 344 pages	Paperback, 144 pages	Paperback, 280 pages
RRP: UK £16.99	RRP: UK £12.99	RRP: UK £15.99
US $27.50 CAN $33.50	US $19.95 CAN $21.95	US $24.95 CAN $29.95

Available in all good bookshops